MEET REMBRANDT

MEET

LIFE AND WORK
OF THE MASTER
PAINTER

GARY SCHWARTZ

REMBRANDT

The crown of fame

History doesn't call many people by their first names. Famous men and women who aren't kings or queens, popes or bishops, knights or noblewomen, go into the history books very formally. To be known to history by your first name, you have to be more than just famous. You have to be a hero to generations after you, nearly a god on earth. Such a man was the Dutch artist Rembrandt.

What Rembrandt is famous for are the paintings, prints and drawings he made more than 350 years ago. His reputation was established by the time he was 25 years old, around 1630. From then on his fame spread. Today he is known to hundreds of millions of people.

Individuals as outstanding and important as that can never be understood completely. The facts of their lives tend to get mixed up with legends. Sometimes they themselves help the legends get started. For example, it was Rembrandt who began calling himself by his first name only. His full name was Rembrandt Harmensz van Rijn. (This brings to mind a story about another first-name immortal, Napoleon. At his coronation as emperor, he seized the crown from the pope and crowned himself. In a

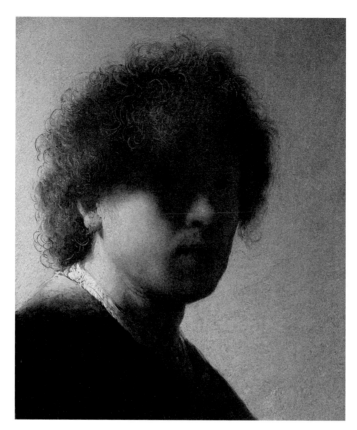

1 The earliest known self-portrait by Rembrandt, about 1626. In the course of his life he was to depict himself repeatedly, helping us to stay on first-name terms with him.

way, Rembrandt took the crown of fame out of the hands of his contemporaries and put it on his own head.)

Great artists are hard to understand for other reasons as well. We are interested in them because of their art. But we cannot always be certain whether a particular work of art is by the master or not. Hundreds of paintings and drawings that are considered original Rembrandts by some experts are doubted by others. And even when they all accept a work as an authentic Rembrandt, chances are they have different opinions concerning its meaning or quality.

A more important reason is that great artists do things no one before them had done in the same way. Standard wisdom

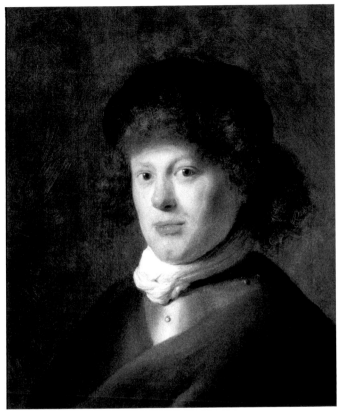

2 In his own self-portrait (fig. 1), Rembrandt left his face in shadow. His friend Jan Lievens painted the young Rembrandt in full light about 1628. He gave him the guise of a soldier or guardsman, which Rembrandt was not. Role playing in the studio was an important part of Rembrandt's artistic practice.

and textbook knowledge often do not apply to their work.

For these reasons, no one can really tell you why Rembrandt is a great artist or what makes a given work by him great. Writers on Rembrandt sometimes make claims of that kind, but they can do so only by ignoring doubts that should not be ignored. In this book I will try to avoid that trap. Instead, I will present the most important facts, as I see them, about his life and his art. For the illustrations I have chosen only works accepted by most present-day Rembrandt experts. However, even that is no guarantee of certainty. 'Facts' are often not as hard as they should be, and the authorship of a work of art is often a mere matter of opinion.

The facts and the illustrations do not speak for themselves. If you want them to help you understand why Rembrandt is so exceptional, you will have to think about them. You will have to compare his life story to the lives of other people from the past and present, his art to the art of other artists. Your image of Rembrandt as a person and an artist will therefore depend on how much you know, how you feel about things, and how you draw your comparisons.

Most of all, you will have to use your imagination. In the chapters on Rembrandt's life and career, try to picture his situation in the various stages he went through. In the discussions of his art, try to let the illustrations convince you that you are seeing the subjects they show: 17th-century Dutchmen, landscapes, Bible scenes, even angels and God himself. Put into words for yourself what it is you are seeing. Appreciating art is not just a visual experience. Rembrandt was out to create pictures that could come to life in our imagination. This happens not through passive looking alone but also through thinking and talking about the stories, concepts and associations he lays before us. Or even, as I am doing, writing about them.

How Rembrandt became
an artist

Early life

On 15 July 1606, Rembrandt was born as the ninth child (there were to be ten) of a well-to-do couple in Holland in the city of Leiden. (The date, taken from the first printed information on the artist, is not certain. The birthday is mentioned only in that one source, and the year is contradicted by other documents, which point to 1605 or 1607.) His father's name was Harmen, so he was called Rembrandt, Harmen's son. In Dutch, this second name comes out as Harmenszoon, usually shortened in writing to Harmensz. That way of naming children was a Dutch practice from a time when no one used family names. If a man named Jan had a son called Peter, the boy would be called Peter Jansz. A daughter Elizabeth would be Elizabeth Jansdr (Jan's daughter). Since Jan is a very common name, you would not be able tell from their names alone that Peter and Elizabeth were brother and sister.

By the time Rembrandt was born, his father did have a family name: 'van Rijn', meaning 'from the Rhine'. In fact, the family house overlooked the river Rhine where it flows out of Leiden. A few steps from the front door, on the city wall, was a windmill

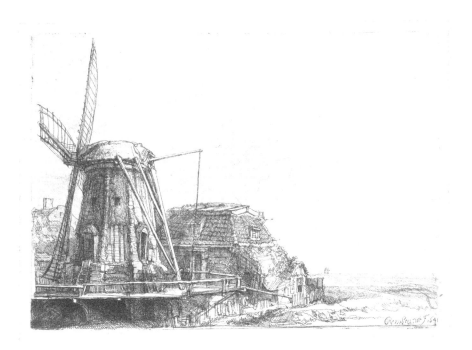

3 Rembrandt's father's mill, similar to this one in Amsterdam that Rembrandt etched in 1641, was located on the city wall in Leiden.

owned by Harmen van Rijn. When Rembrandt looked out of the window, he would see his father's mill, and beyond it the Rhine and the countryside of a part of Holland known as the Rhineland. It must have given him a strong feeling of being where he belonged.

A lot of people in Leiden were poor and had no work, so Rembrandt was fortunate to grow up in a family with a good income. The source of that income was the mill. Farmers from the surrounding area would bring grain there to be ground and sold to bakers and brewers in the city. In good times, the mill could support the family of the miller and his hired hands. Two of Rembrandt's older brothers worked with their father in the mill, and another became a baker, like Rembrandt's grandfather on his mother's side. The family did not have all the luck in the world. Harmen and his eldest son were partly crippled by accidents with guns. They had been drafted into the Leiden

civic guard, a kind of citizens' army, and both of them, at different times, had injured their hands firing their weapons. This must have made it hard for them to do the heavy work in the mill.

Harmen (c. 1567/68-1630) and his wife Neeltje (c. 1568-1640) sent their sons to school. The daughters, like their mother and two out of every three girls of their generation, never learned to read or write. We know this because they signed legal documents with a mark rather than a signature. The older boys probably did not stay in school beyond the age of ten, but when Rembrandt finished his basic education at around that age his parents allowed him to go on to secondary school. The one they sent him to was the best in Leiden, the municipal Latin School, from which a boy – no girls were admitted – could graduate at the age of 13 or 14 and go on to university. Rembrandt's first biographer tells us that his parents hoped he would get a job with the city. But in his final year, he was taken out of school. This may have been for purely personal reasons. According to the biographer, Rembrandt loved painting and drawing so much that he pestered his parents to let him leave school and train to become a painter.

There was another possible reason why Rembrandt's par-

4-5 Rembrandt's father and mother are part of his legend, not for what they did but how they looked. These images, made in 1628 and 1631, have often been said to be likenesses of Rembrandt's parents by their artist son, but this is highly uncertain. The etching of the man's head here illustrated was corrected by the artist.

6-7 Although these self-portrait etchings of 1630 may look like schoolboy scribbles, they are actually refined exercises in the study of emotions and their expression.

ents took him out of school and put aside the idea of working for the government. This was a complicated reason, having to do with religion and politics. Holland was certainly the most tolerant country in Europe in religious matters, but it was not altogether free from internal tension between different faiths. Until the century before Rembrandt lived, almost all Christians in Europe were Catholics. In the 16th century, Protestantism came into being as a challenge to Catholicism. Within Protestantism, there were further splits, such as the Lutherans, the Calvinists and the Mennonites. Twenty years before Rembrandt was born, the Calvinists had replaced the Catholics as rulers of the Northern Netherlands, where Leiden was. (In the Southern Netherlands, the opposite happened, and the Catholics kept all the power.) During Rembrandt's secondary-school days, another revolution occurred. This time the strict Calvinists forced the moderate Calvinists, called Remonstrants, out of office and out of most government jobs. Although Rembrandt's father was a Calvinist, the family included Catholics and Remonstrants, so Rembrandt's chances of getting ahead in the civil service were unsure. The removal of Remonstrants even extended to his

school, where the assistant principal, who later married into Rembrandt's family, was dismissed. These events suggest that Rembrandt may have been taken out of school to avoid unpleasantness with the authorities.

Apprenticeship

With his school career behind him at about the age of 12 or 13, Rembrandt was sent to a painter as an apprentice, or working pupil. At that time, people we consider artists – painters, printmakers, sculptors – were thought of mainly as craftsmen. They were subject to the same rules applied to other trained craftsmen and professionals, like weavers, brewers or surgeons. In the larger cities, most trades and professions were governed by guilds. These were official bodies with boards appointed by the burgomasters (mayors). High guild officers usually came from the same wealthy families as the burgomasters themselves.

The painter to whom Rembrandt was apprenticed was Jacob Isaacsz van Swanenburg, whose father had been burgomaster of Leiden, in the moderate Calvinist party. Van Swanenburg had an adventurous past. Around the age of 20 he moved to Italy, where he married a Catholic girl and raised a family. He kept this secret from his parents. Only after his father's death did he move back to Leiden, in 1615.

If Rembrandt's daydreams about being an artist were like those of other boys his age, we can picture him drawing faces, figures and animals from his memory or imagination, while fantasising about becoming rich and famous through his art. But his apprenticeship will have brought him down to earth. From a noisy schoolroom and a household with ten children he entered a quiet, serious one-man studio. In his late 40s, Van Swanenburg must have looked like an old man to the 13-year-old Rembrandt. The master's wife may have learned to speak Dutch in the four years she had been in Holland, but she and her husband probably spoke Italian at home. It must have been

a strange time for Rembrandt. As for the apprenticeship: if Rembrandt's father was at all a typical Dutch miller, his parting words to Van Swanenburg after putting Rembrandt in his care would have been: 'Work the boy hard.'

An apprentice to a painter *did* work hard. He was not just a pupil. Much of the time he did studio chores like grinding pigments, mixing fluids, stretching canvases, sanding oak panels, brushing in layers of neutral paint to prepare a canvas or panel for the master, running errands and cleaning up. If the boy's father paid the master well enough, he would take the time to give instruction. Since painters were not trained teachers, the quality of their lessons depended on their natural gifts for explaining and demonstrating their craft.

As for the atmosphere in the studio, there are enough stories about Dutch painters who were always drunk, who beat and insulted their apprentices, refused to teach them, cheated them or locked them up. Jacob Isaacsz van Swanenburg was not as bad as that. A relative of his wrote in a family chronicle that he was very good-natured. He taught Rembrandt the fundamentals of art, through practice. The basic technique for learning was copying. An apprentice would copy models like plaster casts of parts of the human body, stuffed animals,

8 Jacob Isaacsz van Swanenburg (1571-1638), *The Last Judgement and the Seven Deadly Sins*, between 1600 and 1638. In the studio of his first master, Rembrandt will have found rich nourishment for his imagination.

drawings and paintings by the master, and engravings of the work of other artists. One of the hardest parts of the training was to stop young artists from drawing from their own imaginations and get them to take their inspiration from art and nature. This was particularly hard for Van Swanenburg, since his own speciality was scenes of the underworld. His paintings are full of monsters and supernatural visions.

After spending several years with Van Swanenburg, Rembrandt went to Amsterdam to complete his apprenticeship in the studio of another Dutch artist who had been to Italy, Pieter Lastman (1583/84-1633). Lastman painted subjects of many kinds, such as landscapes, still lifes and portraits. His main speciality, though, was stories from the Bible and ancient my-

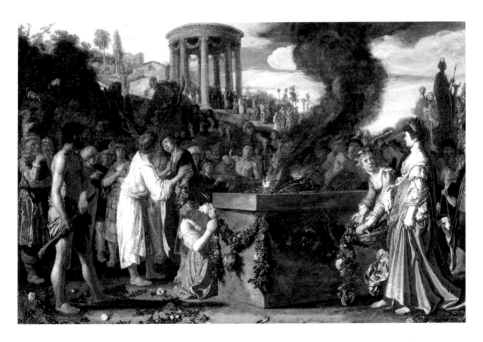

9 Pieter Lastman (1583/84-1633), *Orestes and Pylades disputing at the altar*, 1614. Rembrandt's second master drew his subject matter from the great classical and Christian traditions and his stylistic inspiration mainly from Italian art.

thology. In order to succeed at this work, an artist had to command many different skills. Like every painter, he had to be able to create the illusion of a space on a flat surface, a technique known as perspective. In addition, he had to know the stories he painted and all the characters in them. He had to be familiar with earlier artists' depictions of the same subject. And for a painter to bring his scenes to life convincingly, he had to give each figure an appropriate expression, pose and dress. His scenes had to be placed against a background of landscape or architecture. They had to be decorated with modern or antique objects, and coloured in harmonious or contrasting tones. To do this well required much knowledge and good taste. All of it was part of Rembrandt's training.

Starting on a career

That was a lot to learn for a teenage boy, and it left Rembrandt with little room for developing a style of his own as an artist. But that was not expected of him. Apprentices learned to paint exactly like their masters. The highest compliment that could be paid to a young artist was to say that no one could see the difference between their work and that of their master. Even after apprenticeship, most young painters did their best to imitate the style of an established artist. There were good reasons for this. Works of art were made to be sold, and the closer they resembled works for which there was an existing market the easier they were to sell. Most buyers did not know very much about art. They felt safe if the work of a beginner looked like that of an artist they knew.

Because of this, a painter starting out on his career did not usually become an independent master right away. Typically, he would first work in the studio of his master or another artist, producing paintings in his style. That way he could earn a steady income and save money towards opening a studio of his own. In the meantime, he could show his work to well-wishers among his family and friends. Not until an artist had his own

customers and patrons did it make sense for him to develop an individual style. And even then, most painters found it wise not to stray too far off the beaten track.

Rembrandt was no exception to that rule. When he completed his training he did not take the risk of working on his own. He joined up with another young Leiden painter, Jan Lievens (1607-74). Lievens too had gone to Amsterdam to study with Lastman, some years before Rembrandt. The information we have, which is not complete, suggests that Rembrandt and Lievens shared a studio in Leiden. Some evidence suggests that the work they produced was sold by Lievens's father. The two young painters, still in their teens, practised the specialities they had learned from Lastman. Lievens painted portraits as well, like his first master. Together they made quite an impression. Thanks to their training with Lastman, they had a more sophisticated style than most painters in Leiden. They tackled complicated subjects, which demonstrated a high level of knowledge. Not everyone could appreciate such art. The viewer, too, had to have considerable education to understand it.

Rembrandt and Lievens worked long hours every day, trying out new techniques not only in painting by also in printmaking. They copied the work of Lastman and Rubens and other artists they admired. They even copied each other. Rembrandt and Lievens were the talk of Leiden by the time they were 23 years old. Their reputation spread to The Hague, to the court of the Prince of Orange, and by 1629 at the latest they began working for him, for much more money than they had been earning before. While still living at home, within ten years after leaving secondary school, Rembrandt had become a success.

His career had a lot going for it: he had more money than most of his colleagues, a superior education and training, excellent connections, lots of self-confidence, a generous measure of intelligence and talent, ideas of his own about art, and ambition and daring. He attracted pupils who for a while be-

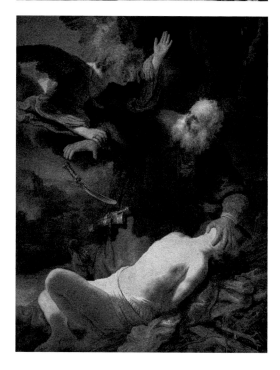

10-11 Nearly all the Bible subjects Rembrandt ever painted had been depicted before him by Pieter Lastman. Rembrandt's visualization of the story of the sacrifice of Isaac, painted in 1635, is an interpretation of his master's version of twenty years earlier, about 1612.

came near clones of the master. The first recorded pupil, who entered Rembrandt's studio as early as 14 February 1628, was the gifted Leiden artist Gerard Dou (1613-75). Dou's early works are still sometimes attributed to Rembrandt. Thanks to Rembrandt's unrivalled skill as a printmaker, many more people could enjoy his work than only those with access to a painting or two.

What he did not have, as we shall see, was the will or ability to parlay these gifts and advantages into sustainable success in life and art. He earned much money, but ended up losing it; he had a classical education, but did not use it a lot; few of his connections with people who helped his career lasted very long; his self-confidence came across to most people as arrogance. His ideas about art were strong and personal, but not clear: scholars are still debating what they were. His business practices, especially with regard to his etchings, were sharp, and were criticised in his lifetime and afterwards. He used his daring not only to break through barriers in art but also to get his way with people, sometimes very brashly. One pupil who wrote about his time with Rembrandt said that the master would bring him to tears with his criticism. With a personality as complicated as that, it is no wonder that Rembrandt's life was full of ups and downs. He made a great stir, became a model for many younger artists, and created works that have moved millions of people. But he also caused unhappiness to people close to him and confusion in the world of art, during his life and after his death.

Who gave Rembrandt his big break and why?

The Prince of Orange

Frederik Hendrik, Prince of Orange, Count of Nassau, Count of Katzenellenbogen, Count of Vianen, Marquess of Veere, etc. etc. etc., was a very busy man. He was the most important person in a dynamic young country, the United Provinces (there were seven) or the Dutch Republic. When he was born in 1584 (he died in 1647), the country had just been formed. Until five years before his birth, the Seven Provinces were not independent. They were part of the 17 Netherlandish provinces belonging to the King of Spain, Philip II. Frederik Hendrik's father, William of Orange (also known as William the Silent, 1533-84), was the leading nobleman of the 17 Provinces. He took his title from the small princedom of Orange in the south of France, but his real power was in the Netherlands. When the nobility and the city governments of the Netherlands got into a conflict with the king, they turned to William for help. He tried to keep all parties together, but did not succeed. In 1579, the seven northern provinces formed a government of their own: the States-General. William went with them. His official title remained the same: stadholder, or deputy. But he meant more than

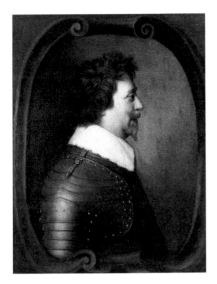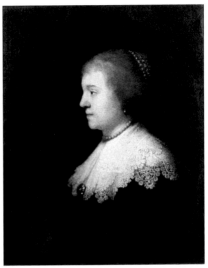

that to the Dutch. They called him the Father of the Country.

He was also the father of eight daughters and four sons. Frederik Hendrik was the youngest of them all. When he was six months old, his father was assassinated by an agent of Philip II. In time, Frederik Hendrik's older half-brother Maurits became stadholder. When he died in 1625, Frederik Hendrik succeeded him.

What kept Frederik Hendrik most busy was his work as commander-in-chief of the armed forces. The Republic was at war with Spain, which was not as far away as it sounds. The Southern Netherlands still belonged to Spain, and territory on the long border between north and south was being lost and won all the time. Frederik Hendrik's strength as a commander was siege warfare. He knew how to surround a city, choke its supply lines, and wait until it surrendered. This was less heroic than fighting pitched battles, but it was less bloody, and the Dutch admired him for it.

Being a prince and leader of an important country like the Netherlands brought more responsibilities than military ones

12-13 Gerard van Honthorst (1592-1656), *Prince Frederik Hendrik (1584-1647)*, 1631. The Utrecht master Gerard van Honthorst was a great favourite at the court of the stadholder. He painted a profile portrait of the prince in 1631.

Rembrandt, *Amalia van Solms (1602-75)*, 1632. A year later, Rembrandt was given the chance to paint a companion portrait of the prince's wife, the German noblewoman Amalia van Solms.

21

alone. Frederik Hendrik's father and brother had raised their family to great prominence, and it was up to him to make sure it stayed there. It helped that his cousin was the King of Denmark, and that he was related by marriage to the King of England. But this was also embarrassing, since his own position was not royal at all. Being Prince of Orange was little more than a formality, since Orange was surrounded by France, and Frederik Hendrik was never even able to visit it. His position as stadholder of the Dutch Republic was an appointment by the States-General. After years of lobbying, Frederik Hendrik succeeded in having the title turned into a hereditary dignity which he could pass on to his son. (You might want to know how the House of Orange did in the long run. Not badly. With some interruptions, they remained stadholders of the Dutch Republic until it ended in 1795. And since 1815, when the Netherlands became a monarchy, they have been its kings and queens. Today the head of the Dutch state is Queen Beatrix of Orange-Nassau, Countess of Vianen, Marchioness of Veere, etc. etc. etc.)

Frederik Hendrik owed it to his status to live well. How could he expect people to take him seriously as a prince if he did not have a palace or two, and if those palaces were not furnished in princely style? The House of Orange did own several palaces, but most of them were located inconveniently outside the Republic, some even in enemy territory. Frederik Hendrik had no choice but to build some of his own. Busy as he was, he did not have time to supervise the construction and decoration himself. For this, he had his people. One was his assistant secretary, a young man by the name of Constantijn Huygens (1596-1687), who was to play an important role in Rembrandt's career.

The prince's right-hand man, Constantijn Huygens
Constantijn's father had been secretary to Frederik Hendrik's father, so the two families went back a long way. When he was a small boy, his father took him along on a diplomatic trip to

14 Thomas de Keyser (1596-1667), *Constantijn Huygens (1596-1687)*, 1627. The man who admired the young Rembrandt and helped him at the court of the Prince of Orange. In this portrait he had himself depicted as the perfect secretary, multitasking to perform his duties for his master Frederik Hendrik.

the south, when the Twelve Years' Truce of 1609 made that possible. As he himself tells us, he charmed everyone in sight with his drawing, improvised poetry and music-making. 'Everyone loves a child prodigy', he wrote modestly in his autobiography. Some of his friends were surprised when Constantijn accepted a job as assistant secretary to Frederik Hendrik. Was this enough of a challenge for someone who knew his languages and literature so well that he could write letters and even poems in Latin, English, French, German, Italian and Spanish, not to mention his native language, which is not easy to write well. Constantijn was one of the great Dutch poets of all times. He played the lute like a professional and wrote hundreds of musical compositions, was able to draw, cast medals and design buildings. Constantijn himself did not think that these talents would be wasted in the service of the Prince of Orange. In fact, by making the most of them, he eventually became chief secretary, and was able to arrange for his son Constantijn Jr to become secretary to Frederik Hendrik's grandson. He also succeeded in becoming a very wealthy man.

When Constantijn was in the field with Frederik Hendrik on

a military campaign, he would entertain him by discussing books on architecture. What they admired above all was the classical building style of ancient Greece and Rome, which had been revived in Italy during the Renaissance. It was only natural that when the two of them agreed on the superior quality of one or another model in a book, Frederik Hendrik would ask him to try to get something of the kind built for him. Constantijn looked for architects who shared the same ideas, and formed a circle of sculptors, carpenters, masons, bricklayers and gardeners. At a time when most building in Holland was in a typical northern European style, the palaces of Frederik Hendrik looked like Italian villas and the new classical palaces of the Kings of France, England and Denmark. In this way, Constantijn helped Frederik Hendrik to distinguish himself. The style and size of his palaces put him in a class with European royalty.

Decorating the prince's houses was a challenge of the same kind. The furniture, woodwork, lamps, tapestries and paintings had to be fit for a classical palace. In Holland it was difficult to find artists and artisans with the ability to produce work of that kind. The artist Constantijn most wanted to employ was the famous Peter Paul Rubens (1577-1640), a Fleming from the Southern Netherlands who as a young man had worked in Italy. Rubens designed tapestries and created grand paintings for royalty all over Europe. He knew Latin and corresponded with scholars as an equal. He collected ancient art, and built a classical house and garden for himself. All of this can be seen in his art. The figures stand in the poses of ancient statues, and are grouped the way they would be in classical reliefs.

Other Flemish artists did come to work for Frederik Hendrik, but not Rubens. The reason was not artistic but political. Rubens was so prominent and capable that he was given a high rank at the court of the King of Spain. On his travels, he performed diplomatic missions, even espionage, for the archenemy of the Dutch Republic. This made it impossible for the chief official of the Republic to honour him with commissions.

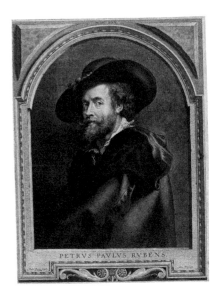

Constantijn went in search of a Dutch artist with the gift of creating classical art. When he saw the work of Rembrandt, he became convinced that he had found him.

15-16 In 1630 the engraver Paulus Pontius (1603-58) made a print after a painted self-portrait by Peter Paul Rubens (1577-1640). In 1631 Rembrandt adopted Rubens's pose and look for a self-portrait print of his own.

Success at court

Rembrandt was in his early 20s when Constantijn Huygens discovered him. He was working in Leiden, mostly for local collectors who were not willing to spend very much money on art. The usual price for a painting was in the neighbourhood of ten guilders. That was enough for renting a room and eating simple food for a month. Etchings and engravings printed on paper went for a guilder or less. This was a far cry from the kind of money being earned by the great Rubens. Depending on the size and complexity of a painting, Rubens charged from 500 to 3,500 guilders for a single canvas.

While Rembrandt's work was attracting attention and praise, there were those who had their doubts about it. The first written notice we have concerning him is an entry in the diary of a man who followed the Dutch art world very closely,

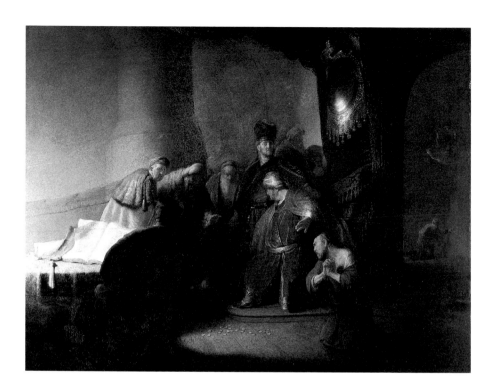

17 Rembrandt, *The repentant Judas returning the 30 pieces of silver to the chief priests and elders*, 1629. The only early painting by Rembrandt concerning which we have a significant written commentary written from the time the painting was made.

Arnoldus Buchelius (1565-1641). He wrote, 'The Leiden miller's son is being praised highly, but prematurely.' In other words, Buchelius thought it was too early to tell whether Rembrandt was going to fulfil his promise. He wrote that in 1628. By the end of that year, Rembrandt was to be put on a pedestal as one of the greatest artists of his time, and was to start earning money on a scale he could only have dreamed of until then.

At the time, Rembrandt was still very close to Jan Lievens. Constantijn was tremendously impressed with both of them. 'Never have I come across such hard work and dedication', he wrote. The quality of their art was little short of miraculous,

considering that they were mere commoners and had medio-cre teachers. Of Rembrandt, Constantijn wrote that he 'cap-tured for the Netherlands the prize of artistic excellence from Greece and Italy'. To us, Rembrandt's paintings do not look anything at all like Greek or Italian art. Why did Constantijn compare them?

Rembrandt better than the ancients

Huygens's meaning becomes clearer when he describes one painting in detail, *The repentant Judas returning the 30 pieces of silver to the chief priests and elders*. Judas had been one of Christ's apostles. He betrayed Christ for a bribe, and felt so guilty about it afterwards that he committed suicide. The painting shows him in deep agony. He has come back to the Jewish priests who bribed him, hoping to relieve his guilt by giving back the money. He has thrown the coins on the ground at the feet of the officials. His twisted pose demonstrates with-out words how sorry he was. When Constantijn says that in this figure Rembrandt combines individual and universal features better than any Greek painter could, we begin to understand what he means. A Greek artist wishing to show a figure in ago-ny would use a standard set of ingredients from older art. Such a figure would be recognised by Greek viewers as a formula for regret. Rembrandt does something else, according to Huy-gens. He observed the actual physical effects of heavy emotion on individual human beings, and used those for his Judas. Therefore, Rembrandt's painting can be seen both as the story of the biblical sinner Judas and as a study of a human being trying to atone for an unforgivable sin.

In writing down his thoughts on the painting, Constantijn Huygens performed a great service for us. Very few Dutch art lovers of Rembrandt's time took the trouble to put into words what they felt about art. Between the lines, Constantijn tells us what was important to him about Dutch art: accurate observa-tion, emotional power, and the ability to make one model stand

18 Willem Isaacsz van Swanenburg
(1580-1612) after Abraham Bloemaert
(1564-1651), *The repentant St Peter*,
c. 1610. Willem Isaacsz was the young-
er brother of Rembrandt's teacher
Jacob Isaacsz. He was such a good
engraver that Rubens sought him out
in Leiden from Antwerp to make
prints after his paintings.

for all of humanity. These are qualities for which Rembrandt's
art is still praised today.

What Constantijn did not know is that Rembrandt's Judas
was not really taken directly from life. The young painter had
been practising for years on twisted figures with clenched fists,
copying examples by other artists, and trying to improve on
them. This does not mean than his version was any less good
than Constantijn said it was. But it reminds us that a good artist
can convince anyone that art is more like life than it actually is.

Constantijn also tells us something about Rembrandt and
Lievens as people. In appearance they were young for their
age, but they behaved like a pair of old men. They were so seri-
ous that they never went out just to have fun. Because they

19 Rembrandt's Judas is a lively variant on Abraham Bloemaert's St Peter.

worked all day sitting or standing still, they were not very strong, and he worried about their health. They were exceptionally intelligent, but annoying to talk to, since they thought they knew it all. The reader of Constantijn's autobiography can nearly hear the arguments between the young artists and the prince's secretary, only ten years older than they. Rembrandt's classical education came in handy at such moments. Lievens, whose brother was a Latin scholar, knew enough Latin to dare sign his name in Latin, calling himself Livius. Rembrandt sometimes used the monogram 'RHL', standing for a Latin form of his name. Not many Dutch artists knew ancient languages. Constantijn must have been impressed.

First success

20-23 Lucas Vorster-
man (1595/96-1674/75)
after Peter Paul Ru-
bens, *The descent from
the cross*. Rubens's
painting was made be-
tween 1611 and 1614, the
print by Vorsterman in

Having found two such promising young artists, Constantijn began showering them with orders for paintings for the Prince of Orange and his court. The legendary story of Rembrandt's first sale of a painting in The Hague, where the court was, fills us in on some other aspects of his personality. He received 100 guilders, which as we have seen was ten times his usual rate. He treated himself to an expensive coach ride back to Leiden, rather than taking the barge, which was slower and cheaper. He was so nervous about having so much cash on him that he was afraid to leave the coach when it stopped at a wayside inn. While the driver and the other passengers were inside, the horses broke loose and carried Rembrandt to Leiden on their own. He left without paying, doubly pleased

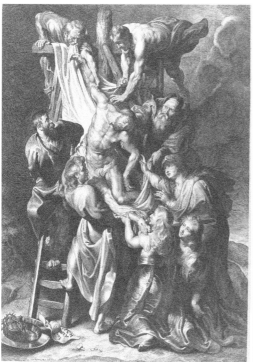

30

to be home quicker than otherwise, and for free.

There is no way to know whether or not this really happened, but Rembrandt's conduct in the story agrees with many facts we know from more reliable sources: he was keen on earning lots of money, liked to live luxuriously, and was no more scrupulous in financial affairs than he had to be.

Apart from the money, Rembrandt's work for the prince brought him other advantages. His work came to the attention of important people. For example, a self-portrait by Rembrandt was given to an English ambassador who in turn gave it to the King of England. At court, Rembrandt came into contact with people who knew a lot about art and artists, and he was able to talk to them about his work. He found out which other painters were admired at court, and was able to study examples of their

1620. Rembrandt painted the subject in 1633 (fig. 21) and brought out a print after his painting in the same year (fig. 22). This is the only etching by him that is a direct reproduction of a painting.

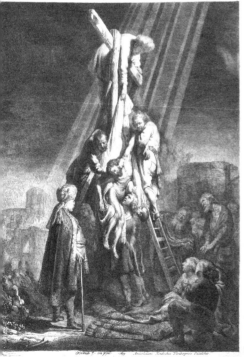

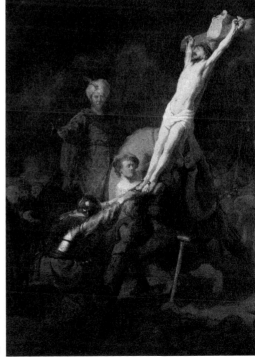

art. The artists with the greatest reputations at the Dutch court were Gerard van Honthorst and Rubens. Naturally enough, Rembrandt tried to see whether he could paint as well as or better than them. Sometimes he was asked to do just that, as when he had to paint a portrait of the wife of the prince to match a portrait of the prince by Honthorst (figs. 12-13). Challenges of this kind help an artist to advance by sharpening his self-criticism.

The greatest challenge was to match Rubens. In painting after painting for Frederik Hendrik, Rembrandt adopted compositions by the great Flemish master. *The elevation of the cross* and *The descent from the cross* are based loosely on famous paintings by Rubens in Antwerp. Even a Rembrandt self-portrait from this period is modelled after one by Rubens (figs. 15-16). This kind of copying was done by all artists at the time, and was not considered cheating. It was a way of measuring yourself against established masters and proving to the outside world that you were as good as them. Rembrandt threw himself into such commissions with body and soul. He was so involved in his work that he painted his own face into *The Elevation* and *The Descent from the Cross*, as helpers both in the execution of Christ and in the care of his body after death (figs. 24-25). He did this for another reason as well. Like a practised public speaker, Rembrandt was always out to persuade his audience that he was showing them the truth. There is no better way of doing this than entering into the story yourself, as if you were depicting a first-person experience.

Rembrandt's work for the Prince of Orange made him one of the best-known artists in the country. Moreover, the prince paid him very well – up to 600 guilders for a single painting, more money than an average Dutchman earned in a year. But the number of commissions he received from the prince was limited. And what would happen, he must have asked himself, if those commissions were to stop altogether? In his mid-20s, in the early 1630s, Rembrandt made a move that helped him cash in on his reputation and safeguard his career. He left his

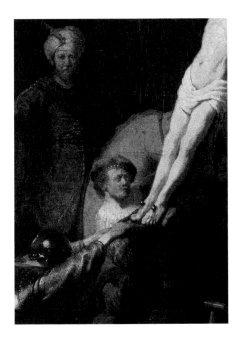

home in Leiden for Amsterdam, where there were lots of
wealthy people who bought paintings.

As things turned out, this was a timely change. If you live on
income from a prince, and if the prince is under no obligation
to continue paying it to you, you have to remain very good at
your work, very nice to the prince and his advisors, and very
lucky. In Rembrandt's case, this combination worked for five
years, and then broke down. What seems to have happened is
that Rembrandt lost the support of Constantijn Huygens. In
1629, in his memoirs, Constantijn called Rembrandt his friend
and the man who brought the glory of Greece to Holland. Four
years later, the next time he wrote about the artist, his tone
had changed. In eight two-line Latin poems, Constantijn found
eight sarcastic ways of saying that a portrait by Rembrandt
looked nothing like the man who sat for it. There seems to be
more to the story than just the truth to life of a painting. The
sitter was a childhood friend of Constantijn's, and Rembrandt's

24-25 Details of
Rembrandt's *Elevation
of the cross* and of
fig. 21, with Rembrandt
as one of the partici-
pants in the Passion of
Christ.

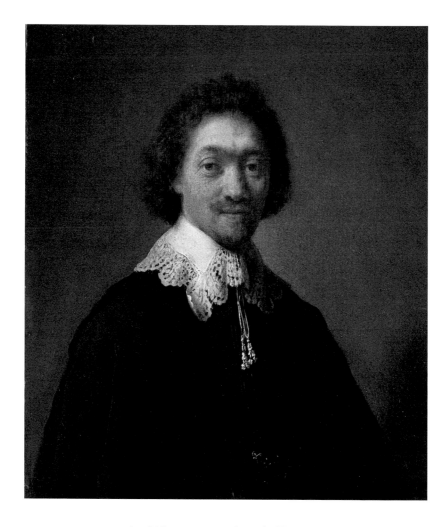

portrait of him was one of a pair. The other one showed Constantijn's own brother. This suggests that something went wrong in the personal relationship between Rembrandt and Constantijn. Rembrandt may have made Constantijn jealous in some way or other. In any event, the commissions from the court stopped coming around this time.

In one way, it is a pity that Rembrandt stopped painting for the court. If he had continued, he might have had more oppor-

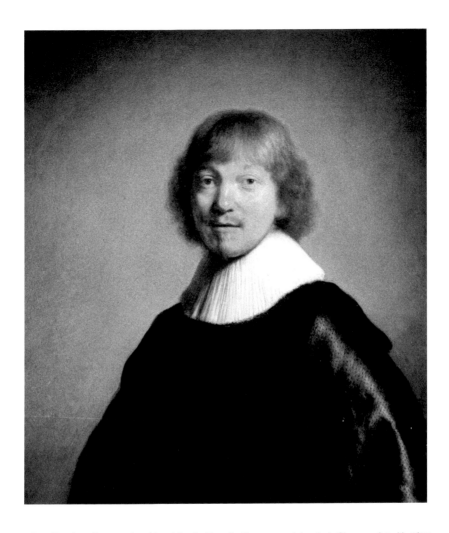

26-27 Rembrandt, portraits of two friends, Maurits Huygens and Jacob de Gheyn, painted in 1632. Maurits was the brother of Constantijn Huygens and Jacob the son of the court artist Jacques de Gheyn. Having their portraits painted as companion pieces was a rare and touching gesture.

tunity to do the kind of work he seemed to like the most: painting stories from the Bible, like the *Judas*. But the move to Amsterdam did not damage his career. In fact, it helped him become richer and more famous than ever.

The young professional

The big city

Amsterdam in the 1630s was one of the great cities of the western world. It was the main European centre of shipping and overseas trade. The harbour was called a 'forest of masts' because of the countless sailing ships from all over the world anchored there at any given time. Amsterdam businessmen controlled much of the traffic in grain from Poland, Russia and the Ukraine. Their companies had a monopoly on trade with the East and West Indies, Japan, Brazil and New Netherland, the later New York. The canals of Amsterdam were lined with warehouses for storing the goods.

The vast sums of money involved made it impractical to pay in cash. A bank was needed to keep track of the traders' accounts. That way, payments could be made just by subtracting a number from one account and adding it to another. To make sure this was done honestly, the city itself opened a bank in the town hall. Traders also wanted to buy shares in each other's ventures. For this purpose a stock exchange was founded. The Amsterdam bank and stock exchange were the most reliable anywhere. They made it possible for people to do business just

28 The central area, with the most irregular streets, is old, medieval Amsterdam. The more geometric areas right and left were added between 1600 and 1650. The white spot in the center is the Dam, where the town hall stood. The larger white spot on the left is

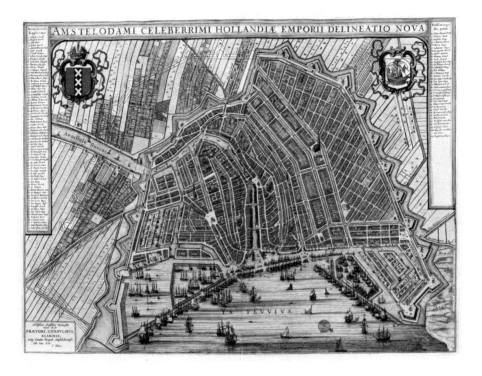

by exchanging cheques and shares instead of moving actual goods or even coins. Once this system was working, it attracted people with money from all over Europe. They made Amsterdam the biggest money market in the world.

The wealthiest Amsterdam families ran the city government. They prided themselves on being more than mere merchants, using their fortunes and power for the good of society at large. They improved living conditions by adding large new areas to the old city. They were proud of their new 'illustrious school', the predecessor of the University of Amsterdam, which was open to professors and students of different religions. (Leiden University, by contrast, was dominated by Calvinists.) Mostly, however, they used their power to increase their profits, and they spent their profits on themselves. Although the government passed laws limiting the open dis-

the Nieuwmarkt, the New Market Square. The main street leading obliquely upward from there takes a sharp break after a few hundred yards. Just beyond that break is the house where Rembrandt lived from 1639 to 1660.

play of wealth, splendid new houses arose in the city and the countryside, decorated with expensive furnishings and works of art. Calvinist preachers told their congregations to dress simply. Maybe they did on Sunday when they went to church. But styles became more and more luxurious. The most expensive jewellery from all over Europe found its way to the grand houses on the new canals: the Prince's Canal, the Emperor's Canal, and most glorious of all, the Gentlemen's Canal. Amsterdam was a boom town.

Among the luxury items in demand were paintings. From all over the Northern and Southern Netherlands and even further, artists moved to Amsterdam to fill the demand. Rembrandt was one of them. Another was a painter and art dealer named Hendrick Uylenburgh (1587-1661). Uylenburgh came from a family of Mennonites, followers of the religious leader Menno Simons (c. 1496-1561). The Mennonites were strict pacifists and enemies of excessive luxury. In the 16th century they had been driven out of the Netherlands to Poland, where Menno's teachings were popular. In the 1620s, Uylenburgh decided it was safe to return. He took over an art shop in the same street where Rembrandt had lived when he was an apprentice to Pieter Lastman, and where quite a few other artists had their studios: St Anthonisbreestraat. It was located in a new area, and it was wider and brighter than the streets in the older part of the city.

An important business partner

With loans from private investors Uylenburgh began a lively trade in painting portraits and group portraits, buying, selling and cleaning paintings, publishing and selling prints, and any other way there was of earning money from art. One of the investors was Rembrandt, who in spring 1631 put 1,000 guilders into Uylenburgh's business. Not long thereafter, Rembrandt moved in with Uylenburgh on St Anthonisbreestraat.

Rembrandt was more than a lodger in Uylenburgh's house.

29 Within a few years after moving to Amsterdam, Rembrandt became eligible for membership in the guild of St. Luke, to which all painters working in the city had to belong. The medal issued to him in 1634 has survived and is kept in the Rembrandt House Museum. The guild archives have not survived. They were destroyed after the guilds were disbanded at the end of the 18th century. They would surely have told us much more about Rembrandt's professional life than we now know.

He became the manager of his studio as well. He trained other apprentices, who painted copies after compositions by Rembrandt that Uylenburgh would sell either in his own shop or through associates.

Uylenburgh was able to provide Rembrandt with lots of well-paid work. One of the first was a group portrait of eight Amsterdam surgeons. Paintings of this kind were very popular in the Northern Netherlands. Most of them show minor officials, like the board members of organisations. Almost every respectable Dutchman belonged to an organisation (called a guild) of all the people in his line of work, or to a civic guard company or the board of a charity. These bodies had an official purpose, but they held social get-togethers as well. The men (and in smaller numbers women) came from the same clans that also controlled government and trade. They could afford to pay for portraits. Another reason why they ordered group portraits is that they were fond of tradition. Once an organisation owned one group portrait, later officers were tempted to add another.

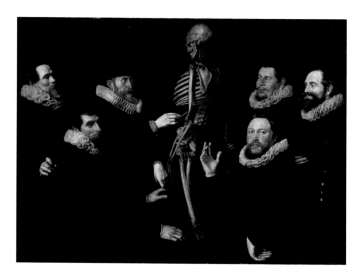

30 Attributed to Nicolaes Eliasz Pickenoy, *The anatomy lecture of Dr Sebastiaen Egbertsz de Vrij*, 1619. Dr De Vrij had been the official lecturer of the surgeons' guild since 1595. In April 1619 he opened a new anatomical theatre, above the weighing hall in the former St Anthony's Gate, premises which the surgeons shared with the painters of the guild of St Luke. This may have been the reason for the surgeons to commission a group portrait.

Rembrandt's first group portrait

The Amsterdam surgeons' guild had three group portraits when Rembrandt was asked to paint a fourth. The older paintings showed guild lecturers teaching anatomy to other surgeons, and Rembrandt also took this as his theme. The lecturer was a man named Nicolaes Tulp (1593-1674), a member of the city council and future burgomaster of Amsterdam. His status helped him in getting a corpse to dissect. This was not an everyday thing, as in medical schools today. No normal citizen would leave his body to science. Only the corpses of executed criminals were put on the dissecting table, and this took a special court ruling. Even when permission was granted, the surgeons had to wait and see whether it would be cold enough

on the day of execution for the body to be preserved for an extra day or two. Demonstrations like the one shown in the painting did not take place more than once every two or three years.

With his background as a painter of stories from the Bible, Rembrandt decided to show the anatomy lecture as a dramatic event. He borrowed the tense poses and attentive expressions of the four listeners closest to the corpse from a Rubens painting of a completely different subject, *Christ and the tribute money*. This helped Rembrandt to accent the religious overtones of his subject. The working of the human body was seen as a sign of God's wisdom, and dissection was a way of revealing it. Rembrandt's painting brought this out more clearly than the other paintings of anatomy lectures, and the surgeons of the guild seem to have valued it highly. Twenty-five years later they invited him back to paint another anatomy lesson.

The anatomy lecture of Dr Nicolaes Tulp is the kind of painting you can look at for a long time, admiring its lifelikeness. It also gives you a lot to talk about. It makes you think about the art of portraiture, the state of anatomical knowledge at the time, and the practice of surgery and medicine in Holland. You wonder what Dr Tulp is saying to his attentive audience. It also inspires you to contemplate death and the meaning of life. Three modern scholars, two art historians and a historian of science, have written entire books about this painting alone. A team of specialists working in the Mauritshuis, the museum where it is preserved, devoted an exhibition and catalogue to it. In Rembrandt's time, we cannot help thinking, it must have been the subject of much admiration and discussion. Unfortunately, no one wrote down what was said about the painting.

Perhaps most important of all for Rembrandt's career, *The anatomy lecture of Dr Nicolaes Tulp* hung in a place where it could be seen by many people. There was no such thing as a museum in the 17th century. For an artist to become widely known, good paintings by him had to hang in places which

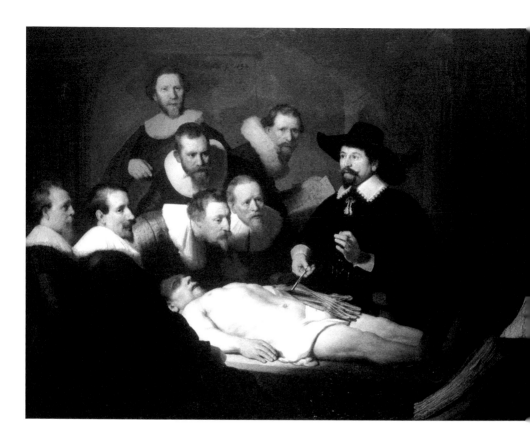

were visited by many people: a palace, a town hall, a courtroom or the hall of a guild. Works by Rembrandt already hung in the prince's gallery in The Hague and the king's gallery outside London. That gave him prestige. The group portrait in the hall of the surgeons' guild in Amsterdam brought him business.

Rising to the top

Rembrandt was not slow to capitalise on his fame. In his first two years in Amsterdam he painted 50 portraits that we know of. Considering the large number of old paintings that disappear in the course of time, it is not impossible that during those years he painted as many as two a week. He charged high pric-

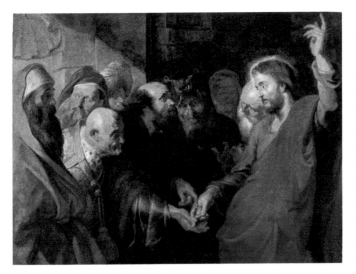

31-32 Rembrandt, *The anatomy lecture of Dr Nicolaes Tulp*, 1632. Peter Paul Rubens, *Christ and the tribute money*, 1612. The interesting resemblances in motif and mood between these paintings show how Rembrandt was able to derive inspiration from remote sources.

es, ranging from 50 guilders for a head to 500 guilders for a life-size, full-length portrait. At this rate, Rembrandt was able to earn as much in a month, painting portraits in Amsterdam, as he had earned for a complicated biblical painting for Frederik Hendrik on which he sometimes worked, on and off, for years. Once again, as when he started painting for the court, Rembrandt's career took a giant leap forward.

The new shift went hand in hand with a change in the subjects Rembrandt painted. When he was living in Leiden and working for The Hague, he painted mainly biblical and mythological subjects. He did a few portraits as well, but not many, partly because Constantijn Huygens thought that Rembrandt was not as good a portrait painter as Jan Lievens. In his first years in Amsterdam, Rembrandt had hardly any time for the Bible and mythology. He became a favourite portrait painter for several groups of Amsterdamers with money. A few of them were Calvinists like Nicolaes Tulp. But most belonged to other religious groups, Catholics, Mennonites, Remonstrants, Lutherans, Jews. This was an important issue for an artist, because religion was not only a matter of personal belief in Holland in the 17th

33-40 Many of Rembrandt's etchings show simple street figures. These were within the reach of all. At the very top of the market he created works like *Christ preaching and healing* (called the *Hundred-guilder print*; c. 1648) and *Peter and John at the gate of the Temple*, 1659. Together with the earlier *Preaching of John the Baptist*, c. 1634, those three works illustrate the spread of the Christian message among the peoples. In those grand compositions we find the same kinds of figures we know from the simpler prints.

century. It was also a major factor in politics and economics, as it still is in many parts of the world today. The Reformed church was the public belief; members of other churches were not admitted to political office. Other religions were tolerated, but only as long as they held their services in private houses. Each group tended to stick together, living in the same neighbourhoods and doing business with their fellow believers both in Amsterdam and in other places in Holland and abroad.

Rembrandt was born into the Calvinist church, but he does not seem to have belonged to a Calvinist congregation or to have joined any other church. With the guidance of Hendrick Uylenburgh he was able to work for all sectors of Amsterdam society.

Uylenburgh not only helped Rembrandt's career as a painter. He also wanted Rembrandt to continue making etchings, which he had started to do in Leiden. Etchings were prints made from copper plates on which the artist drew a design in a technique we will discuss below. A painting could only be sold once, but once an artist had made an etching plate, it could be printed many times, and the prints sold to different customers. Etchings were much cheaper than paintings, so more people could afford them. They were also easier to transport, and could help spread the fame of an artist in distant places.

For Uylenburgh, Rembrandt made a very large etching of *The descent from the cross* (fig. 22). It reproduces one of Rembrandt's paintings for Frederik Hendrik, and looks a lot like a famous altarpiece by Rubens (fig. 20). It announced to

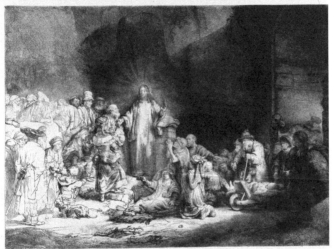

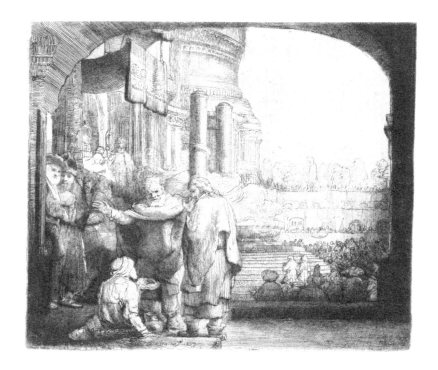

the art-loving public the arrival of Rembrandt as the Dutch Rubens.

Having followed Rembrandt's career until the age of about 28, we now know how he became so well-known. He was presented as a Dutch challenger to the great Rubens by two influential people in Holland: Constantijn Huygens and Hendrick Uylenburgh. Huygens was an important broker of art commissions in The Hague, and Uylenburgh in Amsterdam. When they adopted an artist, other people noticed and talked about it. And Rembrandt gave them enough to talk about. His paintings and etchings provided material for much enjoyment, but also for discussion and debate. His sudden rise to fame and riches, between the ages of 23 and 28, was the most spectacular success story in the Dutch art world. And his private life, as we shall see, was always worth following.

The married man

Saskia Uylenburgh and her family

Hendrick Uylenburgh had a young female cousin named Saskia Uylenburgh (1612-42). She and Rembrandt met and decided to get married. This is not a short version of a long story. It is all we know.

Saskia's branch of the Uylenburgh family had never left the Netherlands. They did not have to, since they were not Mennonites but Calvinists. They lived in Friesland, to the east of the province of Holland, in its capital city of Leeuwarden. Saskia's father, who had died long before, had been a burgomaster of Leeuwarden. He was an adviser to William the Silent, the Father of his Country, and the last man to see William alive before his assassination in 1584. Saskia was clearly in a higher social class than Rembrandt. By marrying her, he gained family ties to more important individuals than his own relatives.

One of these was the husband of Saskia's older cousin Aeltje (1570/71-1644). Johannes Cornelisz Sylvius was a well-known Calvinist minister. When Rembrandt met Saskia, Sylvius was the preacher of the Old Church in Amsterdam, not far from St Anthonisbreestraat. Saskia was closer to Aeltje and Johan-

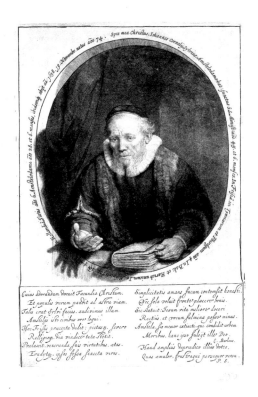

41 Rembrandt, *Johannes Cornelisz Sylvius (1564-1638)*, 1646. The sitter was a distinguished clergyman who became a relative by marriage to Rembrandt when the artist married Saskia. This portrait etching with its complimentary poems on the sitter by well-known Remonstrants was made eight years after the death of Sylvius.

nes than to her Polish Mennonite cousin Hendrick. It seems more likely that when she came to Amsterdam at the age of 20 she would have stayed with them rather than with Hendrick. Nonetheless, by marrying the cousin of Hendrick Uylenburgh, Rembrandt became related to a major art dealer with whom he already worked very closely. The tie was important for both of them. It also complicated their lives. From 1633 on, Rembrandt was an investor in Uylenburgh's business, the supervisor of his studio, and his in-law. Even though Saskia was only destined to live for nine years after the wedding, Rembrandt remained married to the Uylenburghs for the remaining 36 years of his life.

The story of Rembrandt and Saskia's marriage is told in four kinds of document: registries of births and deaths, last wills,

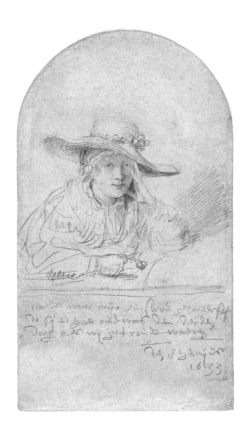

42 Rembrandt, *Saskia in a straw hat*, 1633. The inscription, written by Rembrandt, says that the drawing was made on the third day after Saskia became his wife.

court cases and works of art. The first kind is the saddest. Saskia gave birth to four children, three of whom died before they were two months old. The survivor was the last of the four, a son, Titus. But giving birth to him was too much for Saskia's health. She died half a year later, two months before she would have turned 30.

Rembrandt and Saskia enjoyed their life together. They had such a good time that a relative of Saskia's in Friesland spread gossip that the couple was wasting the family fortune. What business was it of his, you might ask. Well, it was. If Saskia had died without children, or if her children died without children, most of the money she had when she married Rembrandt would go back to her family. This was common practice in Holland, and it made for tension in many families.

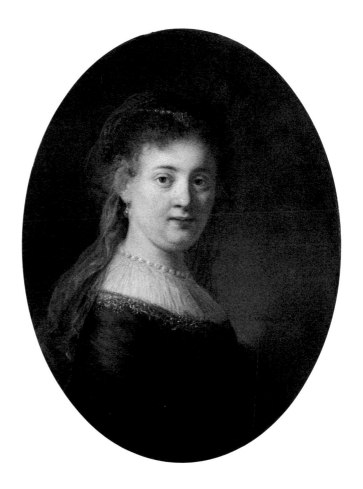

Rembrandt's portrayals of Saskia show her in different ways. Around the time of their marriage, he drew her face in silver-point, a special technique which produces a delicate line that cannot be changed once it is drawn. This very personal portrait is inscribed by Rembrandt: 'My wife when she was 21 years old, the third day after our marriage on 8 June 1633.' Saskia wears a big, floppy straw hat with a ribbon of flowers, and holds a single bud in her hand.

The most spectacular painting of Saskia shows her seated

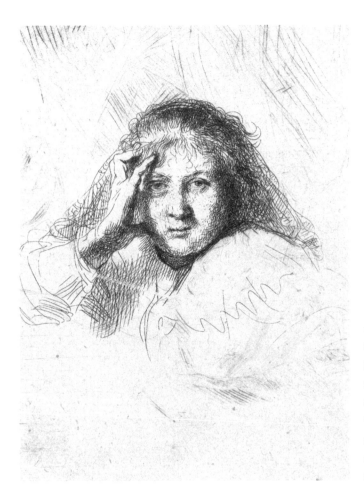

43-44 From 1633 on Rembrandt portrayed Saskia in all media in different forms, as in this formal portrait of 1633 and an etched study plate in which she appears as a vision in the void.

on Rembrandt's lap, looking over her shoulder at us as he raises a glass of wine, a broad grin on his face. Here, as well, the models are playing a part. It has been suggested that Rembrandt is posing as the hero of a Bible story known as 'The prodigal son'. Prodigal means spendthrift, someone who spends lots of money on things he or she doesn't need. In the story, one of the two sons of a wealthy man leaves home and squanders his share of his father's fortune on wine, women and song. When his money runs out, he is reduced to feeding

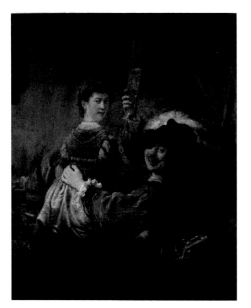

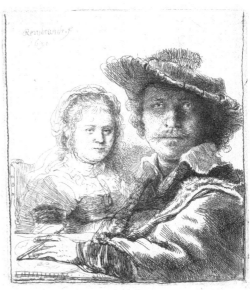

45-46 In the mid-1630s Rembrandt created two images of himself with Saskia, a painting of 1635 in which the two act out flamboyant roles and a real-seeming double portrait etching of 1636. They could not be more different from each other.

pigs in order to stay alive. Swallowing his pride, he returns home, and his overjoyed father prepares a feast. The other son, who has stayed at home and listened to his father all along, is furious. But the father tells him it is right to celebrate, since the other brother 'was dead, and is alive; he was lost, and is found'. The moral of the story is that it is never too late to repent.

It was not unusual for portrait sitters, or artists painting self-portraits, to be shown as actors in a biblical story. The role models for people in those days still came mainly from the Bible. But why would Rembrandt want to depict himself as an unrepentant sinner and his wife as a loose woman? Why the next year would he create an etched self-portrait with Saskia in which they resemble the carousing pair in the brothel? And why would he do it at a time when his wife's family was accusing the young couple of being prodigals themselves? One possible answer is that the images were not intended to be seen as likenesses of the artist and his wife. This is the opinion of several art historians, who doubt that the woman in these

paintings and etchings we call Saskia was her at all. They feel that no personal message was intended or perceived. I do not share this scepticism. I am left with the feeling that these questions are important and as yet unsolved.

One indication that more was at issue is that Rembrandt did not take the gossip lying down. He sued Saskia's relative, claiming that he and his wife were blessed with 'superabundant wealth (for which they cannot be thankful enough to the Lord)', and had no need of Saskia's inheritance to live as well as they did. He lost the case, but his claim was true enough at the time. Rembrandt was the most successful artist in Amsterdam, and his earnings showed it. He had enough capital to engage in business enterprises. In one document he identified himself as a merchant. He indulged in the collecting of art, books, weapons and exotic rarities.

He and Saskia lived in rented rooms for a few years after their marriage. In 1639 they bought a large, expensive house in St Anthonisbreestraat, two doors from where Uylenburgh lived. Here Rembrandt set up an imposing household, with room for home life, reception rooms for customers, a large and small studio and a grand art room for the collection. Rembrandt paid only one-quarter of the price in cash. The seller offered him extended payment terms for the rest, at five percent interest on the balance. It was a big loan, but not out of relation to his income at that time. Unfortunately, Rembrandt did not keep up his payments, with disastrous results that we will find out about in a while.

A speaking portrait

The kind of painting that brought in the most money for the time spent on it was the portrait, and that is what Rembrandt concentrated on for the first few years of his marriage. The most expensive kind was the double portrait of a husband and wife, and it is interesting to study an example, especially since we

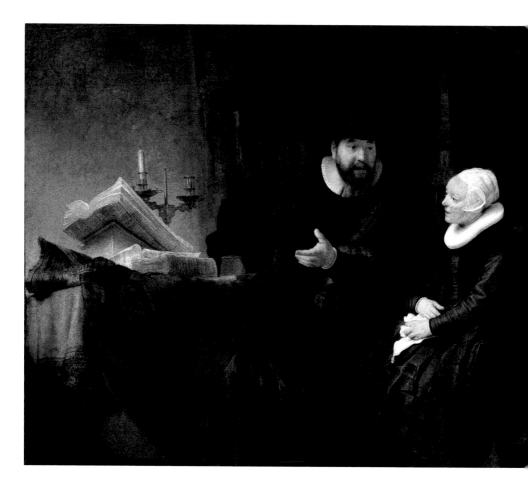

have just looked at a double portrait of Rembrandt and Saskia.

The couple is the Mennonite preacher Cornelis Claesz Anslo and his wife Aeltje Gerritsdr Schouten, painted in 1641. The Mennonites did not have paid clergymen. Any member of the community could preach, and all were expected to earn their own living. Anslo was in the textile business, grain and lumber trade with the Baltic countries, and shipping. He was quite wealthy. He could have asked Rembrandt to paint him in his office, with a view of his ships in the harbour of Amsterdam, but he preferred to have himself shown in his study, 'speaking to his wife about the Bible lying open before him on a table. She, depicted with incomparable art, listens to him attentively

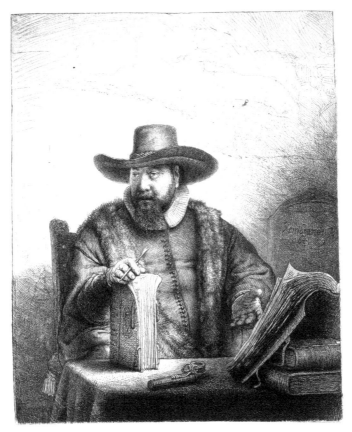

47-48 Rembrandt, *The Mennonite preacher Cornelis Claesz Anslo (1592-1646) and his wife Aeltje Gerritsdr Schouten (1598-1657)*, 1641. Ironically, Rembrandt's largest private commission, for a painting nearly the size of the *Anatomy lecture of Dr Nicolaes Tulp*, was made for members of a church that called for modesty and self-denial. The painting was not all. Rembrandt also made an etching of Anslo in the same year.

and with visible concentration'. The quotation is from a note on the painting written a hundred years later by a great-grandson of Cornelis and Aeltje, who still owned the double portrait.

The famous poet Joost van den Vondel (1587-1679) wrote this poem on the painting:

Aye, Rembrandt, paint Cornelis' voice!
His visible self is second choice.
The invisible can only be known through the word.
For Anslo to be seen, he must be heard.

The quotation and the poem make us look at the painting in a certain way. In the figure of Aeltje, we look for 'visible concentration', and in that of Cornelis for an invisible voice. Aeltje's pose and facial expression do suggest concentration. With her head turned at a slight angle, she gazes intently at nothing in particular, her left hand clenching her kerchief. Cornelis leans towards her, his lips parted and his hand extended the way he would if he were making a point in talking to her. Our imagination is challenged to provide the missing element that binds the two figures: the sound of Cornelis's voice. Although we do not hear it, we are sure that this is a painting of a man talking to a woman about something serious. Clues to what he is saying are provided by the open book, which does seem to be a

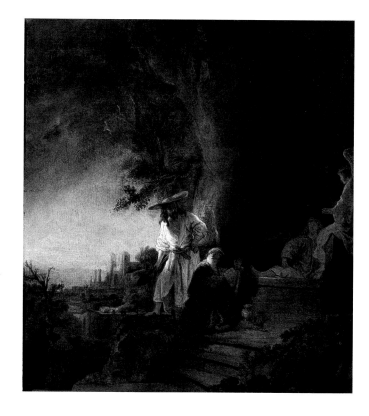

49 Rembrandt, *The risen Christ appearing to Mary Magdalene*, 1638. Angels, like the two at the grave, were part of the real world for Rembrandt and his generation.

Bible, and by the candlestick with one candle, not burning. This detail looks important, like a symbol standing for something else. But we are no longer sure what.

A few years before, Rembrandt painted another kind of dialogue between a man and a woman: the biblical scene of Christ appearing after his death to Mary Magdalen in the form of a gardener. The body of the Magdalen is turned towards the tomb where Christ was buried after the Crucifixion, but her head is turned to look at the risen God. The poet Jeremias de Decker (1609-66), who saw Rembrandt painting the picture, later put the action into these words:

> Christ seems to say 'Marie, don't tremble, I am here,
> It's me. Your master, free of Death's authority'.
> Believing, though not yet with all her heart and mind, she
> Seems poised between her joy and grief, her hope and fear.

De Decker praises Rembrandt for following St John's gospel as closely as can be done in paint. Like Cornelis Anslo's gesture, this too is a way of bridging the gap between word and image. But interpretation is a lot easier when you know the text, and when you have a witness who saw the painter at work.

Interpreting pictures:
a bit of theory

Discussing the paintings of Rembrandt and Saskia and of Cornelis and Aeltje as we have done brings us face to face with a tremendous problem in the study of art. Both pictures look like they have a particular meaning. At first sight we think we understand what they are saying, but when we try to put the meaning into words, we only get so far and no further. Sometimes we come close, as with the Anslos, and sometimes we stay frustratingly distant, as with Rembrandt and Saskia.

Art historians have different ways of dealing with this problem. Some ignore it. They say that the only thing that really matters about art are qualities that cannot be put into words.

Those who do try to interpret images usually begin by comparing depictions of traditional subjects with each other and with texts from literature and religion. This is known as iconography. Iconographers discuss the subject of *Rembrandt and Saskia* (fig. 45). Is it or is it not *The prodigal son in the tavern*? When they have the answer to that question, they will feel that the problem is solved.

Other interpreters will not be satisfied at that point. They would say: 'This is a painting of a man with a woman on his lap,

with a peacock pie in the background. The costumes, gestures and facial expressions all have their own meanings.' They would look at the painting as a set of signs, and try to puzzle out what each sign means, and how they work together in the painting.

There is a school of art historians that stresses the point that every interpretation is linked to a certain time and place in history. The Damien Hirst generation has very different ideas about art from the people who lived during the days of Impressionism. Rembrandt's contemporaries are even further away in time and in mentality. Scholars of this school prefer to study what other people said about works of art, rather than stand behind an interpretation of their own.

Those who take this standpoint to its extreme deny that any interpretation is truer than any other. They claim that everyone who looks at a painting interprets it in his or her own way, no matter what tradition or the history of signs says. If that is so, a work of art cannot be said to have any fixed meaning at all. It only has the meaning we ourselves give it. Such a meaning is valid only for us, and sometimes only for one moment in our lives. All reactions are equal, just as all human beings are equal. Not even the idea of Rembrandt himself concerning the meaning of a work of his own can be said to be truer than what the work means to you, today.

Each of these methods has produced important insights into the meaning of art. But not one of them has convinced all art historians. Most books on art mix them together to produce a method that makes sense to the writer. When you read a book on art, you should try to figure out where the writer stands on the question of interpretation. This is not always easy. Many writers think that *their* method is so sensible that no one could possibly disagree with them, and therefore do not find it necessary to explain themselves.

My own approach combines visual interpretation with historical reconstruction. To my mind, the meaning of a work of art is not contained only in its appearance. Unless we know

what it meant to the artist and to the people he made it for, we miss an important part of its meaning.

Take the painting of Cornelis Anslo and Aeltje Schouten, for example (fig. 47). From documents in the Amsterdam archives we know that Cornelis was the preacher of the Mennonite congregation to which Hendrick Uylenburgh belonged. We also know that Hendrick borrowed a large sum of money from the church in the year the portrait was painted, 1641. As security for the loan, he gave the church 125 etching plates, which must have included work by Rembrandt. In fact, Rembrandt also made an etched portrait of Anslo – alone, without his wife – in 1641 (fig. 48).

These facts may have had an effect on the appearance of the double portrait. They could have led to the decision to portray Anslo as a preacher rather than a merchant. It is not unlikely that Uylenburgh was the one to suggest that Rembrandt paint Anslo, and that he paid part of the fee, in gratitude for the loan from Anslo's church. In that case, the large format of the painting, and perhaps its very existence, came about as a result of the loan. But even if the background circumstances had no influence at all on the appearance of the portrait, they certainly were a part of the picture's meaning to Anslo, to Rembrandt and to Uylenburgh. The poet Vondel was probably involved as well. He was a relative of Uylenburgh's, and had other close ties to the Amsterdam art world in this period.

The creation of this portrait, in other words, was probably part of a complex financial, business and family transaction. Even if the painting had different meanings to each of the individuals involved, still there was a common understanding of why it was made, for whom, and why it was made the way it was. This is what I would call its original meaning. It involves all aspects of the origins of the work: the identity and status of the artist and of the person, institution or market for whom it was made; the subject, iconography, style, quality and price; the personal, social and religious relations between all con-

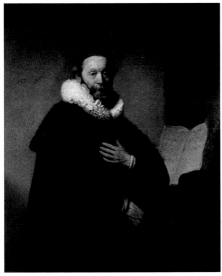
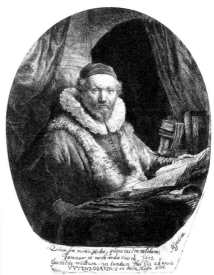

cerned; the use to which the finished work was put; and what was said about it by those who first saw it.

Another Rembrandt portrait of a preacher with a surprising early history is his painting of the Remonstrant leader Joannes Wtenbogaert. In his diary, this important churchman noted that he sat for Rembrandt at the request of a Remonstrant congregant who wanted a portrait of his spiritual guide for himself. This rare record gives us cause to doubt the automatic assumption that a portrait was ordered by the sitter. Behind Rembrandt's *Wtenbogaert*, and perhaps the *Anslo* as well, lay a triangular arrangement that may have influenced his artistic choices.

It is certainly no easier to regain meanings of this kind than it is to interpret a picture on the basis of its appearance alone. For most old works of art, we have no documentation at all concerning the first owner. But complex interpretations of this kind are the ideal towards which I strive in my work as an art historian. Even if the documents needed to prove such an interpretation are missing, I try to form an idea in my mind, based on whatever *is* known about art in that period, which includes as many of the above considerations as possible.

50-51 Rembrandt, *The Remonstrant preacher Joannes Wtenbogaert (1557-1646)*, 1633. The painting is one of the proudest acquisitions of the Rijksmuseum in recent years. The etching joins the names of three of the greatest Dutchmen of all time: Rembrandt, Wtenbogaert and the author of the poem on Wtenbogaert, Hugo Grotius, the father of international law.

The *Night Watch*

Rembrandt was so satisfied with his invention of a speaking hand in the portrait of Cornelis Anslo that he used it again the next year in the largest and most ambitious portrait commission of his career. The main sitter – the 'speaker' – called the painting 'The young Lord of Purmerend, as captain, ordering his lieutenant the Lord of Vlaardingen to let his civic guard march out'. The world knows it better by the incorrect title the 'Night Watch'. If three complete books have been written about the *Anatomy lecture of Dr Nicolaes Tulp*, the number of books written about the *Night Watch* is uncountable. I have written one myself, for a series of Rijksmuseum publications called *Dossiers*, which was published in eight languages!

Rembrandt was asked to paint the *Night Watch* by a company of Amsterdam civic guardsmen. The members were not soldiers, but civilians or burghers who bore arms in defence of the city. There were 20 burgher companies in Amsterdam. Each held target practice, meetings and social get-togethers at one of three halls: one for the crossbowmen, one for the archers, and one for the musketeers. The guardsmen in the *Night Watch* were musketeers, and they met at the Musketeers'

Practice Range, or Kloveniersdoelen. It was located in Precinct II, the district in which Rembrandt and most of his customers lived.

The painting was made for a new meeting hall added to the building in the mid-1630s. All the practice ranges were decorated with group portraits of burgher companies, and it was logical for the musketeers to order some new paintings of this kind for their new hall. But they decided to do something that had never been done before in Amsterdam: to have group portraits made of all six musket companies. An event that took place in this period that made the civic guard more conscious of its own importance may have influenced this decision. In September 1638 the mother of King Louis XIII of France, Maria de' Medici, was received in Amsterdam in a grand ceremonial pageant that lasted for four days. The civic guard played a prominent role in this event. Echoes of the entry are found in several of the group portraits of the musket companies, including the *Night Watch*.

The portraits were painted by the most famous artists in Amsterdam. As each painting was completed and hung, it was certainly compared with the others. We cannot listen over the shoulders of the musketeers as they judged the *Night Watch* against group portraits by Rembrandt's former pupil Govert Flinck (1615-60) or by the distinguished German painter Joachim von Sandrart (1609-88). The best source we have for the reactions to the paintings are some remarks in a book of 30 years later by another former pupil of Rembrandt's, Samuel van Hoogstraten (1627-78). It is worth taking the trouble to read them carefully while looking at the illustration of the *Night Watch*.

'It is not enough for a painter to put his figures next to each other in rows. One sees all too much of that here in Holland in the civic guard halls. True masters succeed in unifying the entire work... Rembrandt observed this principle extremely well in his painting in the guard hall in Amsterdam. Some say he did

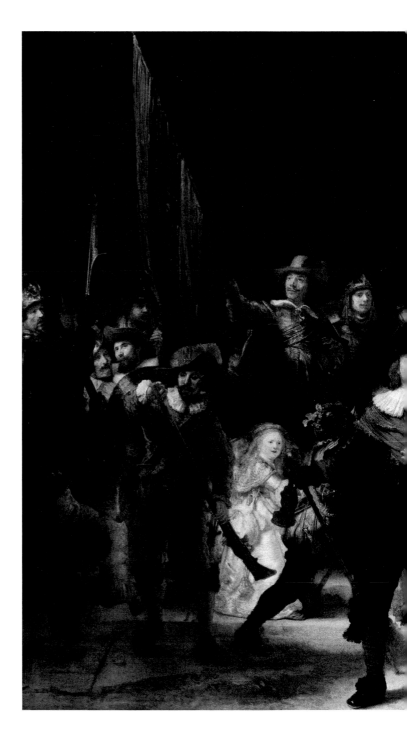

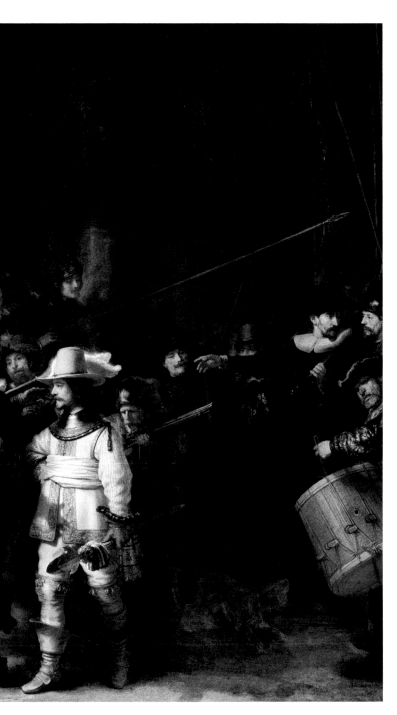

52 Rembrandt,
The Night Watch, 1642

it too well, overemphasising the big picture in his imagination at the expense of the particular images he was commissioned to paint. In my opinion, though, Rembrandt's painting, however deserving of criticism it may be, will outlast all its competitors. It is so painterly in conception, so elegantly posed and so powerful that some people feel that all the other portraits in the hall look like playing cards next to it. Although I would have liked to see him illuminate it with more light.'

There is a lot to think about in those words. They give enough arguments pro and con to reconstruct a 17th-century discussion on the merits and defects of Rembrandt's art. One of the most intriguing remarks is the contrast between the 'big picture' in the artist's imagination and the individual images in the scene. Some of his contemporaries apparently thought that Rembrandt had too much imagination for the good of his art.

Mid-life crises

In 1640 Rembrandt was first mentioned in an art treatise. The Englishman Peter Mundy (c. 1600-67) called him excellent in 'the art off Painting'. In 1641 the Leiden painter-etcher Philips Angel (c. 1618-after 1683) extolled him for the depth of his knowledge and extent of his research into his subject matter, while the Leiden burgomaster Jan Jansz Orlers (1570-1646) published the first biographical note on Rembrandt, calling him 'one of the most esteemed painters of our century'. In that year, too, the Frankfurt publisher and engraver Matthäus Merian (1593-1650) included Rembrandt in his short list of the best printmakers alive. Records have been preserved of the sale of etchings and paintings of his in Paris and Poland. There seemed to be no reason why Rembrandt's career should not go up and up and up.

Then, in 1642, his luck changed for the worse – personally, financially and professionally. On 14 June of that year he lost Saskia. She left him with the nine-month-old Titus. Ten days before she died, she rewrote her will, leaving everything she owned to Titus or, under certain circumstances, to her sisters in Friesland. From that moment on, Saskia's relatives kept an

53 Rembrandt, *A woman in bed (Geertge Dircx?)*, c. 1645-1646. Rembrandt's pupils described one of the women in his life as 'buxom', a description that meets the woman in this sensual painting.

even closer watch on Rembrandt than during his marriage, checking to make sure he wasn't losing or giving away Titus's inheritance. In fact, Rembrandt did give away part of the inheritance, and lost much of the rest, so Titus ended up with less than half of what was due to him.

Even if Rembrandt had been financially successful from then on, virtually every move he made for the remaining 27 years of his life would have created problems for him with the Uylenburghs and the courts. But after 1642, he never again

earned enough for his needs, which made matters much worse. With each passing year, his chances of repaying the mortgage on his house and his debt to Titus diminished, and the financial noose around his neck tightened.

His personal life became a nightmare. With Saskia gone, Rembrandt had a love affair with the nurse who came into his house to take care of Titus, a young widow from Edam named Geertge Dircx (d. 1656). He gave her gifts of jewellery, including some pieces that had belonged to Saskia. After a few years, Rembrandt fell in love with another woman, Hendrickje Stoffels. Realising that he could get into trouble with the Uylenburghs for having given away some of Saskia's jewellery, he tried to get it back from Geertge. She wrote a will leaving most of what she owned, including the jewellery, to Titus, but she also tried to get Rembrandt to marry her. When he refused, she took him to court. He ignored two summonses, and when he appeared at the third hearing, he said, 'The lady claims I slept with her? Let her prove it!' The court believed Geertge without proof, and although it did not go as far as to order Rembrandt to marry her, it did order him to pay her 200 guilders a year for support. The fight turned very ugly, and at a given point Rembrandt conspired with Geertge's brother to have her put away in a penal institution. She was given a 12-year term. After five years, some old friends of hers from Edam found out what happened and were able to have her released, over Rembrandt's threats and protests. The trouble started all over again, but Geertge died within half a year, and that was that, except for a new fight between Rembrandt and Geertge's brother, which also went to court. The brother, a seagoing man, claimed that Rembrandt was harassing him. The artist had asked for him to be arrested on the day his ship was due to sail.

This is a nasty story, and it has created disagreement among art historians. Some, like myself, interpret it to mean that Rembrandt had a streak of unreliability and vengefulness that

54 Rembrandt, *A woman bathing (Hendrickje Stoffels?)*, 1654. If we credit the traditional identification of this woman as Hendrickje, who remained attached to Rembrandt and Titus until her early death, the feelings generated by the painting are all the more tender.

could take on extreme forms. His behaviour, as we know it from other legal documents as well, was often untrusting, leading him into more conflicts than any other Dutch painter we know. This fits in with the opinions about his character written down by some of the people who knew him.

Other scholars are unwilling to believe such a thing of an artist who could create such tender and understanding pictures of human beings as Rembrandt did. They argue that we should not judge the behaviour of someone long dead without knowing more about the facts of the case. (In fact there are more documents about Rembrandt and Geertge than about any other aspect of his life, and more documents about

Rembrandt than any other Dutch artist of the time.)

The connection between the character of an artist and the nature of his or her art is not that simple. A.A. Milne, the creator of the heart-warming Winnie-the-Pooh books, was a distanced and bitter person who was disliked by his son Christopher Robin. In his music, Elvis Presley extols the traditional values and pleasures of the red-blooded country boy, but in real life he was addicted to drugs and underage girls. Rembrandt was, I believe, a case of this kind. His images of Christian faith and human love have moved millions of people for hundreds of years. Somewhere inside, he had instinctive contact with these feelings. He may have wanted to live his life

55 Rembrandt, *Andries de Graeff (1611-78)*, 1639. Like the little girl in the *Night Watch*, the glove on the ground is one of those intriguing details about whose meaning Rembrandt leaves us guessing.

according to them, but he didn't. Does this change the meaning of his art to us? Sometimes it does and sometimes it doesn't. When we look at a painting like the *A woman in bed* (fig. 53) and realise that it may be Geertge just before Rembrandt fell out of love with her, it takes great effort to enjoy it without thinking of the fate in store for the model at the hands of the artist.

Around 1642, Rembrandt's temper got him into trouble professionally as well. He had painted a large, expensive portrait of a man named Andries de Graeff (1611-79). De Graeff was a powerful figure in Amsterdam, with the kind of connections that could make or break a career. He was vain and stingy, and in his dealings with Rembrandt he lived up to his reputation. For some reason or other, he refused to pay the agreed-upon fee of 500 guilders for his portrait. Rembrandt, instead of compromising quietly, sued De Graeff. He won the case and got his money, but lost the backing of De Graeff and his family. All the other painters who worked on the group portraits in the musketeers' meet-

57-60 The two etchings of cottages (1641) and the one of Amsterdam (1640) were always collected and studied separately until the art dealer Theo Laurentius noticed that when you line them up they form a continuous panorama of Amsterdam seen from across the IJ River. New discoveries about Rembrandt never stop.

61 Rembrandt, *St Jerome beside a pollard willow*, 1648. In a few lines above the saint a rocky landscape is sketched in. Rembrandt displays supreme self-confidence in this combination of highly finished and very sketchy passages.

62 Rembrandt, *The three trees*, 1643. Country and city, sky and earth, people at work, making love in the shadows, three trees that prompt profound associations. This is one of Rembrandt's iconic, inexhaustible masterworks.

63 Rembrandt, *The stone bridge*, c. 1638. The slight knick in the church tower in the right background was the defining mark of the tower in Ouderkerk aan de Amstel, a two-hour walk from Rembrandt's house. The stone bridge outside Ouderkerk lay in the location depicted, if one assumes that the image was reversed left-right, as Rembrandt sometimes did.

ing hall were given new work in later years by the captains they painted or their families. All except Rembrandt. For more than ten years after 1642, he painted no more group portraits and no more portraits of any of the wealthy Amsterdamers whose business had been his main source of income. His finances never recovered, and neither did his peace of mind.

It was during these years that Rembrandt created his drawings, etchings and paintings of landscapes. The subjects range from simple views in the streets around his house and country cottages to vistas of real locations and imagined scenes of exotic places and sacred subjects placed out of doors. This phase in his art coincided with the time in his life when he was experiencing the worst difficulties at home. Whether or not it is mere coincidence we cannot say. My own feeling is that there is indeed a link. When Rembrandt's life settled down in later years, he stopped making landscapes.

Patrons with taste

Jan Six

The first Amsterdam patrician to give Rembrandt work after the *Night Watch* was called Jan Six (1618-1700). A wealthy man who did not have to work for a living, Six spent his time and money on art, books and the theatre. He wrote plays himself, and helped other playwrights get their works produced and published.

When an artist works for someone who is not sure of his own taste, or for the open market, he or she is better off sticking to traditional, accepted forms of art. But Six, like Constantijn Huygens, was a connoisseur, a judge of quality in art. Sophisticated patrons or customers such as these like to be surprised with something new, so the artist can experiment. The first piece of work Six ordered from Rembrandt was an etched portrait. It shows the patrician in an unusually informal pose, leaning casually in a windowsill, reading. The books and manuscripts on the chair in the foreground and the painting on the wall identify Six as a lover of literature and art. The sabre on the table suggests an interest in fencing. The technique of the etching, with its many shades of black, is very refined, showing the artist to be a virtuoso in his craft.

64 Rembrandt, *Jan Six
(1618-1700)*, 1647. A later
patron of Rembrandt's
ordered from him an
etched portrait 'of the
same quality as that of
Mr Jan Six', but never
got it.

As in the portrait of Anslo, here too Rembrandt tries to cap-
ture in a picture something invisible: not the sitter's voice, but
his mind. If you look closely at the etching, you will notice a
certain peculiarity in the lighting. The part of Six's face turned
away from the window would normally be in shadow. In the por-
trait, it is lit – not directly, but by light reflected from the open
page. Symbolically, this tells us that Six's mind is illuminated
by his intellectual efforts. A poem on the etching by the theatre
publisher Jacob Lescaille (1611-77) reinforces this interpreta-
tion. The title says that Six is shown 'in his library, practising

the learned sciences', and begins: 'Behold Jan Six, as he re-
freshes his soul by diligently searching out, in books, the core
of wisdom.' This draws the viewer into the sitter's inner world.
We are curious to know what he is reading and thinking, just as
we would like to know what Anslo is saying and how his wife is
reacting to it.

Another etching by Rembrandt linked to Jan Six is a land-
scape traditionally known as *Six's bridge*. If the portrait etch-
ing of Six is a composition in black, the landscape is an equally
virtuoso scene in white, making maximum use of the sheet of
paper itself as background. Jan Six gave Rembrandt still more
opportunities to display his wizardry, in drawings, a frame de-
sign, an illustration for a printed play by Six, and most spec-
tacularly in a painted portrait of the patrician.

The painting combines two different styles, roughly compa-
rable to the black and white modes of the two etchings. The
sitter's face and hair are dense and detailed, while the hands
and garments are dashed off with as few brushstrokes as pos-
sible. Yet the overall effect of the painting is perfectly unified.

65 Rembrandt, *Six's bridge*, 1645. The same church tower as in fig. 63 is now seen in the distance from a different angle.

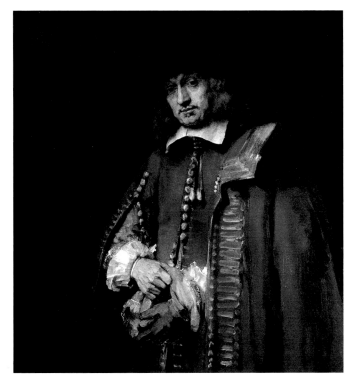

66 Rembrandt, *Jan Six*, 1654. While it is still owned by the descendants of the sitter and cannot normally be seen, the portrait is now subject to an arrangement with the Rijksmuseum by which it will be on view in the museum for certain periods.

A little poem by Jan Six on a portrait of his brother Pieter tells us something about how he looked at art:

The painter is quite pleased; he's managed to express
The inner Pieter Six by means of outwardness.
His giving nature shows in golden-yellow hair
And purity of soul in features white and fair.

The painting of Jan Six pleased not only, we assume, the painter, but also the sitter and his descendants. Eleven generations later, the portrait is still in the family.

Through Jan Six, Rembrandt's contacts in the theatrical world, which were already considerable, took on new meaning. In 1648 he created an etching to be published in the luxu-

67 Rembrandt, *Medea, or The wedding of Jason and Creüsa*, 1648. Other female victims of male sexual drive depicted sympathetically by Rembrandt were Susanna and Lucretia.

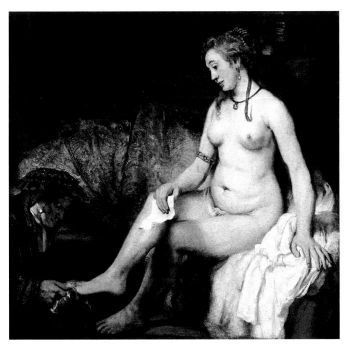

68 Rembrandt, *Bathsheba with King David's letter*, 1654. A painting that in our times is regarded as one of Rembrandt's greatest achievements was disparaged for centuries because the model failed to live up to prevailing notions of female attractiveness.

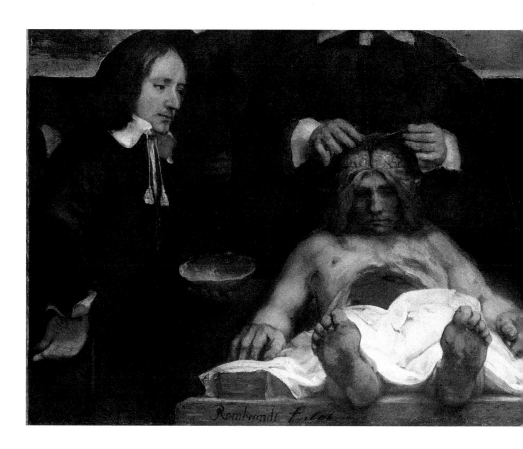

rious edition of Six's play *Medea*, on the tragic ancient heroine who murdered her children to punish her treacherous husband Jason. While other writers treated Medea as the incarnation of evil, Jan Six portrayed her in the first place as a victim. The same sentiment marks Rembrandt's painting of the biblical Bathsheba (1654), who was forced into adultery by King David. Other artists showed her only as a sex object; Rembrandt lends her the dignity of a tragic heroine.

Playwrights who were being helped by Six, and fellow patricians who served on the theatre board, began working with Rembrandt. In this way, he began once more to get commissions from Amsterdam officials. The same thing happened in the medical world. In the 1650s, Six married the daughter of Dr Nicolaes Tulp, who by then had risen to the rank of burgomaster.

70 Rembrandt, *Aristotle with a bust of Homer*, 1653. Antonio Ruffo, who ordered this painting from Rembrandt, was not his only important patron in Italy. Recently it has been learned that in 1668 an aristocratic family from Genoa ordered a large altarpiece from him. Although he accepted the commission, Rembrandt did not deliver the painting.

This connection helped Rembrandt get a second commission for a group portrait of Amsterdam surgeons and for portraits of individual physicians. Thanks to the protection of Six, the worst effects of Rembrandt's fight with Andries de Graeff were finally being overcome. By then Rembrandt was 50 years old.

Unfortunately for both men, Rembrandt was not able to keep the friendship of Jan Six. The rupture came around 1656, and had to do with money. We know of two transactions that went

wrong. One was a loan from Six of 1,000 guilders that neither Rembrandt nor his co-signer was able to repay. The other had to do with a contract concerning the purchase by Six of three paintings from Rembrandt. When a disagreement arose over the terms of the contract, Rembrandt claimed to have lost the document. The details are unknown, but they were unpleasant enough for the painter and his patron never to work together again. We can only dream about what might have been had Six and Rembrandt continued to stimulate each other.

Don Antonio Ruffo

In 1653 another important patron entered Rembrandt's life. In far-off Messina, Sicily, the aristocrat Don Antonio Ruffo (1610/11-1678) spent much of his time and fortune on his vast art collection. Hearing of the Dutch artist who was praised so highly and collected so widely, he commissioned first one, then two more paintings by Rembrandt. One of them has the same subject as a drawing Rembrandt made for Jan Six, *The poet Homer reciting his verses*. For Six, Rembrandt drew Homer in his patron's friendship album, along with a drawing of Six's mother as the goddess of wisdom, Minerva. The *Homer* for Ruffo formed part of a larger ensemble as well, including the world-famous *Aristotle with a bust of Homer*. These works show us Rembrandt exerting himself at the top of his intellectual and artistic abilities. Unfortunately, once more, his lack of social grace and respect for his fellow man once more broke him up. He got into a needless quarrel with Ruffo, writing insultingly, 'I believe that connoisseurs are few and far between in Messina.' The Sicilian nonetheless went on to buy a large number of etchings by Rembrandt, but the support that he might have offered had Rembrandt remained on good terms with him went up in thin air.

71 Rembrandt, *Jeremiah lamenting the destruction of Jerusalem*, 1630. The lamentations of Jeremiah were beloved texts for Dutch Christians. In 1629 a new Dutch translation was published in Haarlem.

72 Rembrandt, *Jacob blessing the sons of Joseph,* 1656. The blind old patriarch Jacob, in blessing the sons of his son Joseph, crossed his arms to favour the youngest son with his right hand. Joseph objected angrily, according to the Bible. At first Rembrandt painted him that way, as X-rays reveal. In the final version, however, he gave Joseph a benign expression.

Menasseh ben Israel

One of the most striking personalities of Rembrandt's Amsterdam was the Jewish rabbi, scholar, printer and publisher Menasseh ben Israel (1604-57). Menasseh was born in Madeira in a Portuguese Jewish (Sephardi) family that moved to Amsterdam in 1610. He was one of the few prominent members of the Jewish community who maintained significant ties in the Christian world as well. Menasseh was a teacher, a writer and an entrepreneur, the founder of the first Hebrew-language press in Amsterdam. He provided rabbinical source books for Christian as well as Jewish scholars.

It was long believed that Menasseh was a close neighbour of Rembrandt's and that the two men were friends. By extension, Rembrandt was believed to have been a friend of Jews in general and sympathetic towards their faith. His numerous depictions of subjects from the Old Testament were said to reflect sympathy for the People of the Book.

The notion that Rembrandt was a friend of the Jews has a sentimental side. The models for many works with a warm atmosphere have been identified as Jews. These attractive notions do not, however, stand up to scrutiny. A Rembrandt etching that was said to portray Menasseh has been shown not to be him. Evidence of personal contact between the two men is lacking. The documentary evidence there is of Rembrandt's relation with Jews all involve conflicts, accusations and disagreements. Finally, the Old Testament was not thought of by Reformed Christians as a book belonging to the Jews. Because they did not accept the divinity of Christ, the Jews had lost their status as the chosen people. That role was now filled by Christians. Dutch Calvinists thought of themselves as living Israelites, persecuted by the great (Catholic) powers and rescued by the Lord. During Rembrandt's lifetime there was very little margin for sympathetic relations between Christians and Jews, and we have no indication that Rembrandt moved into that margin.

Nonetheless, Rembrandt did create four etchings as illus-

trations for a religious tract written (in Spanish), printed and published in 1655 by Menasseh. The book is called *Piedra gloriosa*, the glorious stone. The stone in all four prints is the same one, returning as an instrument of salvation through the ages of Jewish history, from the time of the patriarch Jacob to that of King David, the prophet Ezekiel and the hero Daniel. It forms part of an extraordinary enterprise in which Menasseh was engaged to pave the way for the coming of the Messiah and bring about the end of days. Rembrandt's illustrations, two of them dark and difficult to make out, add mystery to Menasseh's mysticism.

We know nothing more about the origins of the prints except that they exist. They were not used for long, however. Within a short time after Rembrandt made his plate for the set, they were copied by a Jewish engraver, Salom Italia, with at least one important change. The face of God in Rembrandt's *Vision of Daniel* made way for an empty oval. After the initial printing, Salom's prints replaced those by Rembrandt. Intriguing as it is, this incident does not add up to a meeting of minds between the artist and the rabbi.

73 Rembrandt, Four illustrations for *Piedra gloriosa*, a book by Menasseh ben Israel. Rembrandt etched the illustrations, which were inserted at different places in the book, on a single plate. After a certain number of impressions were printed, the plate was cut up and the individual images were printed separately.

74 Rembrandt, *The Jewish bride*, c. 1665. Concerning the subject of this painting opinion is heavily divided. The most widely accepted idea is that the couple are Isaac and Rebecca. However, ties with plays on the Amsterdam stage have also been pointed out.

The last years

By the time of the falling out with Six, Rembrandt's entire life was a shambles. His finances, since 1642, were an accident waiting to happen. The accident occurred in 1652, when Holland went to war with England, and everybody in the country needed cash. The people who had lent Rembrandt the money to buy his house started to put serious pressure on him to pay them back. For a few years he was able to keep them happy with small sums and promises, while doing what he could to protect himself should the roof cave in. Some of the measures he took were not legal, and they got him into fresh trouble. In one last effort to raise cash, he hired a hall for a three-week auction of most of what he owned, probably including a lot of his own work and that of other artists. The proceeds were not enough, and in any case he did not use them to pay off any of his old debts. This must have been the last straw for the lenders.

In the end, bankruptcy was inevitable. Between 1656 and 1660, the courts sold all of Rembrandt's possessions, including his house, at a series of auctions for the benefit of the lenders. Most of them had to settle for a fraction of what they had lent Rembrandt. This painful arrangement did not release him

75 Rembrandt, *Titus van Rijn in a Franciscan habit*, 1660. Rembrandt created several etchings and paintings of St Francis and men in Franciscan habit. The fact that he painted his own son in this way seems to indicate that he and Titus were not antagonistic toward Catholicism.

from all the claims that might be brought against him. For further protection, he took shelter behind Titus and Hendrickje, who lived with him as his common-law wife and who worked as a dealer in second-hand goods. Rembrandt had his wife and son form a company for which they were entirely responsible, with all they owned. He worked for the firm as an adviser in exchange for a liberal allowance. Everything he painted became the property of the firm, not of the painter, so it could not be seized by people to whom Rembrandt owed money.

Titus became Rembrandt's pupil, specialising in paintings of still lifes and animals. He was a well-meaning boy, and tried to help his father, but that was more than he – or anyone else – could do.

Once he found himself in the office of a Leiden publisher who needed an engraved portrait to illustrate a book. This kind of print is made by cutting grooves into a sheet of copper with a sharp wedge called a burin. When the grooves are filled with ink and passed through a press with a sheet of paper covering the plate, the ink is taken up by the paper to leave a printed impression. Titus knew that Rembrandt owned burins, although he used them only for special effects on etchings. Etchings are printed in the same way as engravings, but the grooves are made differently – not by a cutting instrument, but by acid which bites into the plate through a layer of wax in which the artist sketches the subject with a needle. Etching plates produce fewer impressions than engravings before they wear out. Rembrandt was famous for his etchings, and the publisher asked Titus if he could for once make an engraving. Titus said, 'Are you kidding? My father can engrave with the best of them.' The publisher gave him the commission, but when Rembrandt delivered the portrait, it was etched and not engraved. It was refused by the publisher, and poor Titus had to swallow his shame.

Rembrandt had one more great opportunity to restore his reputation in his last years. He was invited by the burgomas-

76-77 Rembrandt,
*Jan Antonides van der
Linden (1609-64)*, 1665.
Abraham van den
Tempel, *Jan Antonides
van der Linden*, 1660.
When Rembrandt
received the commis-
sion for a portrait print
of this Leiden professor
of medicine, the sitter
had already died. The
close resemblance
between his etching
and a painting by the
Leiden master Abraham
van den Tempel makes
it likely that the painting
served as model for the
print. The space under-
neath the likeness was
reserved for a text on
the sitter, but this was
never filled in.

ters of Amsterdam to paint a huge canvas for the new town hall. The ground-floor corridors were decorated with scenes of the revolt of the early inhabitants of Holland, the Batavians, against the Roman army that occupied their country. Rembrandt's assignment was to paint the *Oath of Claudius Civilis*, a fierce, one-eyed Batavian leader. His painting hung in the town hall only for half a year before it was removed, for reasons unknown to us, and returned to the artist, unpaid for. He cut it down to the central subject, in which form it still survives as an impressive fragment.

Not all of Rembrandt's experiences in the final decade of his life gave cause for bitterness. In 1660 an anthology of poetry was published in Amsterdam in which five different authors paid tribute to Rembrandt's art. One of them was the same Jeremias de Decker we met above as commentator on Rembrandt's painting of Christ and Mary Magdalen. In a later poem, written about 30 years after they first met, De Decker expressed warm personal feelings as well as high artistic regard for Rembrandt. The subject of the poem was a portrait of De Decker that Rembrandt painted for his friend at no charge.

In the 1660s Rembrandt painted two final group portraits,

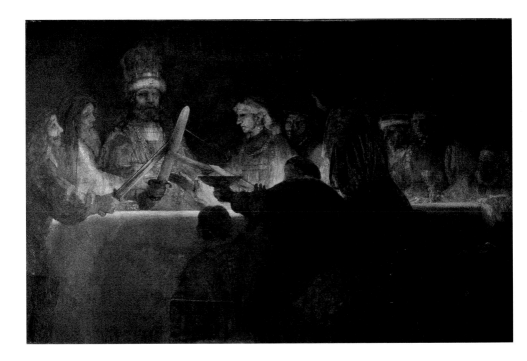

78 Rembrandt,
*The oath of Claudius
Civilis*, 1661-62. It is still
a mystery how this
remnant of Rembrandt's
largest painting ended
up in Stockholm, where
it is recorded since 1766.
It is not a bad thing that
several of his most
famous works are
abroad, where they
became an important
part of the local culture.

one of a corporate body – *The syndics of the drapers' guild* – and another of a family. These and some other portraits of dignified sitters show that Rembrandt had not fallen completely out of favour with society.

Yet Rembrandt's last years could not have been sadder. When he was 57 years old, Hendrickje Stoffels died in a plague outbreak at the young age of 37. She left him a daughter named Cornelia (1654-78). Rembrandt was 62 when Titus was married, to a cousin of his from the Uylenburgh family, Magdalena van Loo (1641-69). Magdalena became pregnant a few months after the wedding, but Titus may never have known it: when she was in her third month at the latest, Titus died, 26 years old. Magdalena, who was the same age as Titus, died a month after giving birth to a daughter, named Titia after her dead father. If there was any mercy to speak of in this sequence of tragic young deaths, it is that Rembrandt lived to see the birth

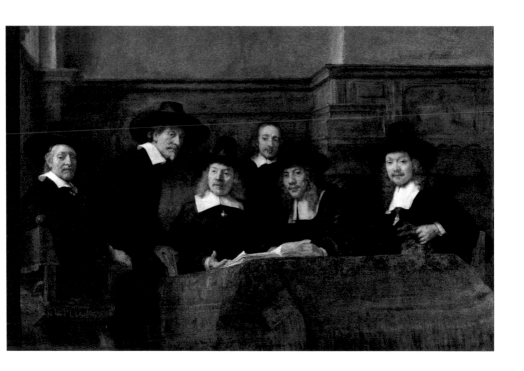

of Titia and that he died two weeks before his daughter-in-law Magdalena, on 4 October 1669. He was 63 (or – if born in 1607 – 62) years old. He lived longer than any of his brothers and sisters, wives and children. It was a life of bright early hope followed by disappointment and bitterness. It was a life that changed the world of art.

79 Rembrandt, *The syndics of the drapers' guild*, 1662. As in the case of the earlier anatomy lectures and the *Night Watch*, this painting was commissioned as part of a tradition linking Rembrandt's work to earlier portraits of former holders of the dignities and offices of the sitters. This is only one of the ways in which his art was deeply embedded in his society.

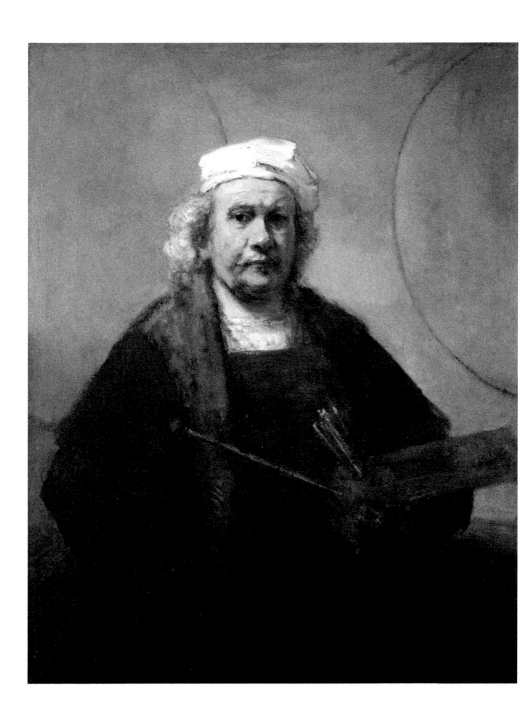

Afterlife

The story of Rembrandt's life and career tells us a lot about the circumstances under which his art was created, especially the paintings. It tells us how he became famous in his time. But it does not answer our first question: how did Rembrandt become a legend for all times? The answer to that lies in the way he was treated by posterity, the centuries following his own.

Although Rembrandt's star was in decline when he died, he was still one of the best-known painters of Europe. And he was known for something specific. Certain ways of painting and certain subjects were associated with him. Paintings with deep brown and grey shadows relieved by a single highly lit area are called Rembrandtesque. The same word is applied to paintings of dilapidated buildings, poorly dressed old men and women sunk in thought, and nude women with sagging breasts and rimpled thighs. Rembrandt is credited with depicting people the way they really are rather than the way they would like to be or think they should look. He is admired for painting models whose faces give expression to their true feelings and reflect life in all its disappointments and sadness. Another Rembrandtesque group of works are the many self-portraits

80 Rembrandt, *Self-portrait*, c. 1661-62. More than most other artists, Rembrandt is present in our minds as a person. This is due in large part to the many images of himself that he created. This particular self-portrait adds mystery to his appearance through the circular and straight lines behind him.

99

the artist created, and the even larger number of copies after them.

Posterity also knew what Rembrandt was *not*. His art was not elegant, decorative, courtly or literary. It portrayed the human soul, and not the values of organised religion. From what we know about the historical Rembrandt and his work, we can see how these ideas became attached to him after his death. But we also know that they are not very accurate. Rembrandt *did* work for the court, he was not against making decorative paintings, he had close ties to the world of literature, and his main aim in painting people was not to show them as naturally as possible. But labels can take on a life of their own. Within a short time after Rembrandt's death, any work of art which matched the clichés was said to be by him. Not even the signature of another artist could stop this from happening. It is easy enough to paint over a signature.

As long as the world, and the art market, valued elegance above naturalness, Rembrandt was not regarded very highly. Compared with an Italian artist like Raphael (1483-1520), he was considered crude. His character as a person was thought to correspond to his art. The stories told about him emphasised his love of money and impoliteness. Still and all, his art was admired and traded eagerly, if at lower prices than work by Raphael or Rubens. In the period before art history became a special field of study, when only a few artists' names were well known, Rembrandt's was one of them.

In the 19th century, as ideals of political and social life changed, so did ideas about art. With the decline of the European courts, old standards of grace and beauty began to seem artificial. Artists of the 19th century looked for true-to-life ways of depicting ordinary human emotions and experiences. When this happened, Rembrandt's art began to look better than it had before. The qualities for which it had been put down became cause for praise. As his work rose in value, more paintings and drawings than ever were said to have been made

by him. 'Rembrandtness' was found in thousands of works that had nothing to do with the real Rembrandt.

For the artist's new admirers, it was important to believe that Rembrandt was a sincere person, whose pictures of humanity came from the heart. This was also essential to the Dutch patriots who promoted Rembrandt as a national hero. In 1853 they erected a statue to him in Amsterdam, in rivalry with a newly placed statue of Rubens in Antwerp. They put him forward as the greatest Dutch artist of all times, claiming that the stories about his bad character were the result of jealousy and ignorance. Since most of the 18th-century stories *were* fabrications, it was not hard to disprove them. (Few of the documents from Rembrandt's own life were known at the time.)

Outside Holland, Rembrandt became a hero of liberals and anti-aristocrats throughout Europe. They saw 17th-century Holland as a model for the kind of societies they wanted to establish. The art of the Dutch Republic provided the proof that the lives of ordinary men and women could be glorified – even sanctified – by artists devoted to the real world rather than to the dogmas of the church or the fancies of the courts. Rembrandt was the best example of this. He became a near god, worshipped in part for paintings which he did not paint and for human qualities which he did not possess.

In the 20th century, scholars became stricter about defining which works are and which are not by Rembrandt. Increasingly, they judge authorship on the basis of technique, style and quality. Present-day connoisseurs think that these things are more measurable than the mood of a work and its effect on our emotions. On this basis, more than 1,000 paintings and drawings have been removed from the list of Rembrandt's works. Art historians have also been forced to face the fact that Rembrandt was less honest than his admirers believed.

None of this has damaged Rembrandt's artistic reputation any more than it was hurt by the inflated admiration of the 19th century. In fact, the reasons given today for Rembrandt's

greatness are usually the same ones that were invented then, though they are now applied to different paintings.

Apparently, what has made Rembrandt a legend is a combination of ingredients that are not necessarily linked. There are reasons dating back to his own lifetime, such as his prominence from youth onwards, his great talent, and his close relations with poets and playwrights who talked and wrote about him. After his death, those who wrote nasty things about him turned him into a symbol of inelegance and boorishness. When those bad characteristics were reinterpreted positively as sincerity and naturalness, his reputation benefited. He was also singled out from among all other Dutch artists as a national hero.

These things could have happened to any of the thousands of talented and well-known artists the world has seen, no matter what his or her art was like. In the case of Rembrandt, something else came along. It began with supreme artistic quality. Comparing a well-preserved, undeniably autograph work by Rembrandt to that of any contemporaneous Dutch artist, Rembrandt's superiority it visible in many ways. His eye and hand and mind are joined in a way with which few other artists have ever been endowed. Every stroke of the brush or pen or needle contributes visibly to the overall effect, if you look closely enough.

However, supreme quality is not the whole story. That phrase suggests something that can never be taken away, while it has happened time and again that a painting thought to be by Rembrandt became legendary, only to be cast down from the heights when art historians began having doubts about it. A famous example is *The man with the golden helmet* in Berlin. This canvas was nearly worshipped for 80 years, from 1890 to 1970, as one of the greatest paintings in the world. But when art historians began doubting whether it was really by Rembrandt, the high quality it was first thought to possess somehow faded in the eye of the beholder. There must be something

81 Rembrandt pupil or follower, *The man with the golden helmet*, c. 1650. The most famous ex-Rembrandt of the moment. Most de-attributed Rembrandts disappear quietly into limbo. Increasingly, however, they are being taken seriously not only as historical documents but also as works of art.

else about Rembrandtesque paintings, aside from their artistic quality, that makes them special.

One factor that has contributed to Rembrandt's long-lasting fame is that he was not only a people's artist and a connoisseur's artist, but also an artist's artist. Other artists liked to copy him or improvise on his manner. In the documentation of the Netherlands Institute for Art History in The Hague, the largest single group of paintings are copies after Rembrandt and works assigned to the Anonymous Rembrandt School.

From the beginning to the end of his career, Rembrandt trained younger artists in his own style. Many more followers imitated or appropriated his work on their own. Their adaptations may not have the same quality, but they do have an appealing 'Rembrandtness'. Even outright forgeries, if at all successful, add to Rembrandt's fame when they are made and again when they are unmasked.

Rembrandt's popularity among other artists goes beyond the media he practised. Photographers and cinematographers, too, have been inspired by him. The art historian Anne Hollander goes further: 'Light and shade, the essential components of photographic and cinematographic art, were first given true freedom by Rembrandt, their decisive enlargement into the imaginative world. Moving camera poetry was made possible by him. It was Rembrandt who single-handedly raised the stakes, and set the standard the camera would have to meet.'

Rembrandt is kept perpetually alive because his story and his art offer qualities that can be freshly discovered – invented might be a better word – by generation after generation. The interests displayed in this book, in the religious and political context of his art and his personality, are typical of some members of my own generation. We too, however, are carried along by the times. The ways in which contemporary artists deal with such matters as the appropriation of images or the exploitation of fame make us think anew about how Rembrandt did these things. Because of his many-sidedness, we encounter Rembrandt constantly in artistic and general culture. That keeps him fresh and keeps his admirers in his thrall.

List of illustrations

1 Rembrandt (1606-69), *Self-portrait*, c. 1626. Oil on panel, 22.6 x 18.7 cm. Rijksmuseum, Amsterdam. Acquired with the support of the Rembrandt Association, the Prince Bernhard Foundation and the Netherlands Ministry of Culture, Recreation and Social Work.

2 Jan Lievens (1607-74), *Portrait of Rembrandt van Rijn (1606-69)*, c. 1628. Oil on panel, 57 x 44.7 cm. Rijksmuseum, Amsterdam (on loan from a private collection).

3 Rembrandt, *The windmill*, 1641. Etching, 14.5 x 20.8 cm. Rijksmuseum, Amsterdam.

4 Rembrandt, *Head of an old woman*, 1628. Etching, 6.6 x 6.3 cm. Rijksmuseum, Amsterdam.

5 Rembrandt, *Head of an old man*, 1631. Etching, 11.9 x 11.7 cm. Rijksmuseum, Amsterdam.

6 Rembrandt, *Self-portrait in a cap, open-mouthed*, 1630. Etching, 5 x 4.5 cm. Rijksmuseum, Amsterdam.

7 Rembrandt, *Self-portrait open-mouthed, as if shouting*, 1630. Etching, 8.3 x 7.2 cm. Rijksmuseum, Amsterdam.

8 Jacob Isaacsz van Swanenburg (1571-1638), *The Last Judgement and the Seven Deadly Sins*, between 1600 and 1638. Oil on panel, 28 x 88 cm. Rijksmuseum, Amsterdam.

9 Pieter Lastman (1583/84-1633), *Orestes and Pylades disputing at the altar*, 1614. Oil on panel, 83.2 x 126.1 cm. Rijksmuseum, Amsterdam.

10 Pieter Lastman, *The angel stopping Abraham from sacrificing his son Isaac*, c. 1612. Oil on panel, 40.3 x 31.5 cm. Rijksmuseum, Amsterdam.

11 Rembrandt, *The angel stopping Abraham from sacrificing his son Isaac*, 1635. Oil on canvas, 193 x 132 cm. Hermitage, St. Petersburg. bpk / Roman Beniaminson.

12 Gerard van Honthorst (1592-1656), *Frederik Hendrik, Prince of Orange (1584-1647)*, 1631. Oil on canvas, 77 x 61 cm. The House of Orange-Nassau Historic Collections Trust, The Hague.

13 Rembrandt, *Amalia van Solms (1602-75)*, 1632. Oil on canvas, 68.5 x 55.5 cm. Musée Jacquemart-André, Paris. Institut de France.

14 Thomas de Keyser (1596-1667), *Portrait of Constantijn Huygens (1596-1687) and his clerk*, 1627. Oil on panel, 92.4 x 69.3 cm. The National Gallery, London.

15 Paulus Pontius (1603-58) after Peter Paul Rubens, *Self-portrait*, 1630. Engraving, 36.8 x 27.7 cm. Rijksmuseum, Amsterdam.

16 Rembrandt, *Self-portrait*, 1631. Etching with additions in black chalk by the artist, 14.8 x 13 cm. British Museum, London.

17 Rembrandt, *The repentant Judas returning the 30 pieces of silver to the chief priests and elders*, 1629. Oil on panel, 76 x 101 cm. Private collection, England.

18 Willem Isaacsz van Swanenburg (1580-1612) after Abraham Bloemaert (1564-1651), *The repentant St Peter*, c. 1610. Engraving, 26.8 x 17.2 cm. Rijksmuseum, Amsterdam. Acquired with support from the Rembrandt Association.

19 Detail of fig. 17.

20 Lucas Vorsterman (1595/96-1674/75) after Peter Paul Rubens, *The descent from the cross*, 1620. Engraving, 58.5 x 43.5 cm. Rijksmuseum, Amsterdam.

21 Rembrandt, *The descent from the cross*, 1633. Oil on panel, 89.4 x 65.2 cm. Alte Pinakothek, Munich. bpk / Bayerische Staatsgemäldesammlungen.

22 Rembrandt, *The descent from the cross*, 1633. Etching, 53 x 41 cm. Rijksmuseum, Amsterdam.

23 Rembrandt, *The elevation of the cross*, 1633. Oil on panel, 96 x 72 cm. Alte Pinakothek, Munich.

24 Detail of fig. 23.

25 Detail of fig. 21.

26 Rembrandt, *Maurits Huygens (1595-1642)*, 1632. Oil on panel, 31 x 24.5 cm. Hamburger Kunsthalle, Hamburg. bpk / Hamburger Kunsthalle / Elke Walford.

27 Rembrandt, *Jacob de Gheyn III (1596-1641)*, 1632. Oil on panel, 29.5 x 24.5 cm. By permission of the Trustees of Dulwich Picture Gallery, London.

28 Map of Amsterdam from Joan Blaeu's publication of city maps, *Tooneel der steden*, Amsterdam 1652. Library of the University of Amsterdam, Amsterdam.

29 Rembrandt's membership medallion in the Amsterdam guild of St. Luke, 1634. Rembrandt House Museum, Amsterdam.

30 Attributed to Nicolaes Eliasz Pickenoy (1588-1653/56), *The anatomy lecture of Dr Sebastiaen Egbertsz de Vrij (1563-1621)*, 1619. Oil on canvas, 135 x 186 cm. Amsterdam Historical Museum, Amsterdam.

31 Rembrandt, *The anatomy lecture of Dr Nicolaes Tulp (1593-1674)*, 1632. Oil on canvas, 216.5 x 169.5 cm. Royal Picture Gallery Mauritshuis, The Hague.

32 Peter Paul Rubens, *Christ and the tribute money*, 1612. Oil on panel, 144.1 x 189.9 cm. Fine Arts Museums of San Francisco, San Francisco.

33 Rembrandt, *Beggars receiving alms at the door of a house*, 1648. Etching, drypoint and engraving, 16.5 x 12.8 cm. Rijksmuseum, Amsterdam.

34 Rembrandt, *The Holy Family crossing a brook on the flight into Egypt*, 1654. Etching and drypoint, 9.5 x 14.4 cm. Rijksmuseum, Amsterdam.

35 Rembrandt, *Peasant family on the tramp*, c. 1652. Etching, 11.3 x 9.3 cm. Rijksmuseum, Amsterdam.

36 Rembrandt, *John the Baptist preaching*, c. 1634. Oil on canvas on panel, 62.7 x 81.1 cm. Gemäldegalerie, Staatliche Museen zu Berlin. bpk / Gemäldegalerie, SMB / Jörg P. Anders.

37 Rembrandt, *Christ preaching and healing the sick, called 'The hundred-guilder print'*, c. 1648. Etching, drypoint and burin, 28.2 x 39.5 cm. Rijksmuseum, Amsterdam.

38 Detail of fig. 37.

39 Rembrandt, *Two studies for the paralysed woman lying at Christ's feet in The hundred-guilder print* (fig. 37), c. 1648. Pen and brush, with white body colour, 10.1 x 12.2 cm. Rijksmuseum, Amsterdam.

40 Rembrandt, *Peter and John healing the cripple at the gate of the Temple*, 1659. Etching, drypoint and burin, 18 x 21.9 cm. Rijksmuseum, Amsterdam.

41 Rembrandt, *Johannes Cornelisz Sylvius (1563/64-1638)*, 1646. Etching, drypoint and burin, 27.8 x 18.8 cm. Rijksmuseum, Amsterdam.

42 Rembrandt, *Saskia in a straw hat,* 1633. Silverpoint drawing on vellum, 18.5 x 10.7 cm. Kupferstichkabinett, Staatliche Museen zu Berlin. bpk / Kupferstichkabinett, SMB / Jörg P. Anders.

43 Rembrandt, *Saskia Uylenburgh (1612-42)*, 1633. Oil on panel, 65 x 48 cm. Rijksmuseum, Amsterdam. Acquired with support from the Rembrandt Association.

44 Rembrandt, *Saskia*, c. 1637. Etching, 12.7 x 10.3 cm. Rijksmuseum, Amsterdam.

45 Rembrandt, *Rembrandt and Saskia as the prodigal son in the tavern*, c. 1635. Oil on canvas, 161 x 131 cm. Gemäldegalerie Alte Meister, Dresden. bpk / Staatliche Kunstsammlungen Dresden / Hans-Peter Klut.

46 Rembrandt, *Self-portrait with Saskia*, 1636. Etching, 19.5 x 9.5 cm. Rijksmuseum, Amsterdam.

47 Rembrandt, *The Mennonite preacher Cornelis Claesz Anslo (1592-1646) and his wife Aeltje Gerritsdr Schouten (1598-1657)*, 1641. Oil on canvas, 173.7 x 207.6 cm. Gemäldegalerie, Staatliche Museen zu Berlin. bpk / Gemäldegalerie, SMB / Jörg P. Anders.

48 Rembrandt, *The Mennonite preacher Cornelis Claesz Anslo,* 1641. Etching and drypoint, 18.8 x 15.8 cm. Rijksmuseum, Amsterdam.

49 Rembrandt, *The risen Christ appearing to Mary Magdalene*, 1638. Panel, 61.5 x 50 cm. The Royal Collection. © 2009 Her Majesty Queen Elizabeth II.

50 Rembrandt, *The Remonstrant preacher Joannes Wtenbogaert (1557-1646)*, 1633. Oil on canvas, 130 x 101 cm. Rijksmuseum, Amsterdam.

51 Rembrandt, *The Remonstrant preacher Joannes Wtenbogaert*, 1635. Etching, 25 x 18.7 cm. Rijksmuseum, Amsterdam.

52 Rembrandt, *Officers and other civic guardsmen of District II of Amsterdam, under the command of Captain Frans Banninck Cocq and Lieutenant Willem van Ruytenburch, known as the 'Night Watch'*, 1642. Oil on canvas, 379.5 x 453.5 cm. Rijksmuseum, Amsterdam (on long-term loan from the City of Amsterdam).

53 Rembrandt, *A woman in bed*, c. 1645-46. Oil on canvas, 81.1 x 67.8 cm. The National Gallery of Scotland, Edinburgh.

54 Rembrandt, *A woman bathing (Hendrickje Stoffels?)*, 1654. Oil on panel, 61.5 x 47 cm. The National Gallery, London.

55 Rembrandt, *Andries de Graeff (1611-78)*, 1639. Oil on canvas, 199 x 123.5 cm. Gemäldegalerie Alte Meister, Museum Schloss Wilhelmshöhe, Kassel. bpk / Museumlandschaft Hessen.

56 Rembrandt, *View on Nieuwezijds Voorburgwal, Amsterdam*, c. 1657. Black chalk, 8.6 x 16.4 cm. Rijksmuseum, Amsterdam.

57 Rembrandt, *Landscape with a cottage and a large tree*, 1641. Etching, 12.9 x 31.9 cm. Rijksmuseum, Amsterdam.

58 Rembrandt, *View of Amsterdam from the northwest*, c. 1640. Etching, 11.1 x 15.2 cm. Rijksmuseum, Amsterdam.

59 Rembrandt, *Landscape with a cottage and a hay barn*, 1641. Etching and drypoint, 12.9 x 32.1 cm. Rijksmuseum, Amsterdam.

60 Panorama composed of figs. 57-59.

61 Rembrandt, *St Jerome beside a pollard willow*, 1648. Etching and drypoint, 18 x 13.3 cm. Rijksmuseum, Amsterdam.

62 Rembrandt, *The three trees*, 1643. Etching with drypoint and burin, printed with light plate tone, 21.3 x 27.9 cm. Rijksmuseum, Amsterdam.

63 Rembrandt, *The stone bridge*, c. 1638. Oil on panel, 29.5 x 42.5 cm. Rijksmuseum, Amsterdam. Acquired with the support of the Rembrandt Association and A. Bredius.

64 Rembrandt, *Jan Six (1618-1700)*, 1647. Etching, drypoint and burin, 24.6 x 19.1 cm. Rijksmuseum, Amsterdam.

65 Rembrandt, *Bridge on the estate of Klein-Kostverloren, with a view of Ouderkerk aan de Amstel, known as 'Six's bridge'*, 1645. Etching, 12.5 x 22.3 cm. Rijksmuseum, Amsterdam.

66 Rembrandt, *Jan Six*, 1654. Oil on canvas, 112 x 102 cm. Six Collection, Amsterdam.

67 Rembrandt, *The wedding of Jason and Creüsa*, frontispiece to the play *Medea* by Jan Six, 1648. Etching and drypoint, 24 x 17.6 cm. Rijksmuseum, Amsterdam.

68 Rembrandt, *Bathsheba with King David's letter*, 1654. Oil on canvas, 142 x 142 cm. Musée du Louvre, Paris.

69 Rembrandt, *The anatomy lecture of Dr Joan Deyman (1619-66)* (fragment), 1656. Oil on canvas, 100 x 134 cm. Amsterdam Historical Museum, Amsterdam.

70 Rembrandt, *Aristotle with a bust of Homer*, 1653. Oil on canvas, 143.5 x 136.5 cm. The Metropolitan Museum of Art, New York. Purchase, special contributions and funds given or bequeathed by friends of the Museum, 1961. © 2007 The Metropolitan Museum of Art / Art Resource / Scala, Florence.

71 Rembrandt, *Jeremiah lamenting the destruction of Jerusalem*, 1630. Oil on panel, 58 x 46 cm. Rijksmuseum, Amsterdam.

72 Rembrandt, *Jacob blessing the sons of Joseph*, 1656. Oil on canvas, 175.5 x 210.5 cm. Gemäldegalerie Alte Meister, Museum Schloss Wilhelmshöhe, Kassel. bpk / Museumlandschaft Hessen, Kassel.

73 Rembrandt, Four illustrations for *Piedra gloriosa* (1604-57), 1655. A book by Menasseh ben Israel (1604-57). Etching, burin and drypoint, 28 x 16 cm. Rijksmuseum, Amsterdam.

74 Rembrandt, *'The Jewish bride'*, c. 1665. Oil on canvas, 121.5 x 166.5 cm. Rijksmuseum, Amsterdam (on long-term loan from the City of Amsterdam).

75 Rembrandt, *Titus van Rijn (1641-68) in a Franciscan habit*, 1660. Oil on canvas, 79.5 x 67.7 cm. Rijksmuseum, Amsterdam. Acquired with the support of the Rembrandt Association.

76 Rembrandt, *Jan Antonides van der Linden (1609-64)*, 1665. Etching, drypoint and burin, 17.3 x 10.5 cm. Rijksmuseum, Amsterdam.

77 Abraham van den Tempel (1622/23-1672), *Jan Antonides van der Linden*, 1660. Oil on canvas, 88.5 x 71 cm. On loan to the Stedelijk Museum De Lakenhal, Leiden, since 1922. Royal Picture Gallery Mauritshuis, The Hague.

78 Rembrandt, *The oath of Claudius Civilis* (fragment), c. 1661-62. Oil on canvas, 196 x 309 cm. Nationalmuseum, Stockholm. © Hans Hinz – Artothek.

79 Rembrandt, *The syndics of the drapers' guild*, 1662. Oil on canvas, 191.5 x 279 cm. Rijksmuseum, Amsterdam (on long-term loan from the City of Amsterdam).

80 Rembrandt, *Self-portrait*, c. 1661-62. Oil on canvas, 114 x 94 cm. The Iveagh Bequest, Kenwood House (English Heritage), London.

81 Rembrandt pupil or follower, *The man with the golden helmet*, c. 1650. Oil on canvas, 67.5 x 50.7 cm. Gemäldegalerie, Staatliche Museen zu Berlin. bpk / Gemäldegalerie, SMB, Kaiser Friedrich-Museums-Verein / Jörg P. Anders.

Meet Rembrandt: life and work of the master painter is published by the Rijksmuseum and Nieuw Amsterdam *Publishers*.

Author
The art historian Gary Schwartz is the author of numerous books on Dutch art. These include *Rembrandt, his life, his paintings: a new biography* (1985) and *The Rembrandt book* (2006).

Design
Nanja Toebak

Lithography
Nauta en Haagen Oss b.v.

Printing
Drukkerij Wilco b.v., Amersfoort

© Copyright 2009 edition: Rijksmuseum, Amsterdam; Nieuw Amsterdam *Publishers*
© Copyright 2009 text: Gary Schwartz
© Copyright 2009 photographs: Rijksmuseum, Amsterdam, and other institutions mentioned in the captions and list of illustrations.

ISBN 978 90 868 9057 6
NUR 646

For further information on the activities of the Rijksmuseum and Nieuw Amsterdam, please visit www.rijksmuseum.nl and www.nieuwamsterdam.nl.